Phaidon Architecture Guide

Dublin

Edited by John Graby and Deirdre O'Connor

Phaidon Press Limited
140 Kensington Church Street
London W8 4BN

First published 1993

© 1993 by Phaidon Press Limited

ISBN 0 7148 2861 0

A CIP catalogue record for this book is available from
the British Library

Printed in Hong Kong

Contents

Maps

Preface

Dublin's image has been filtered through its literature, where the city is often portrayed as a semi-derelict backdrop. In recent years it has been known mainly through books and press reports which concentrate on the losses to the city's heritage. By contrast, in the 18th century Dublin was regarded as the 'second city' of the empire and although examples of classical architecture have been lost, Dublin remains one of the finest Georgian cities in the British Isles. This should not be seen as evidence of any particular concern for architectural heritage, except perhaps recently, but as the result of political and economic forces. The Act of Union between Britain and Ireland in 1800 brought a decline in activity and ensured that most of Dublin's 18th century architecture survived. Unlike many other European capitals Dublin escaped the ravages of World War II, and remained largely intact throughout the economic boom of the 1960s, despite urban blight caused by ambitious traffic plans, mostly unrealized and now largely abandoned, and the changes brought about by widespread office and commercial development.

Although Dublin is a low-density city with vast suburbs spreading across the western plane, the inner city, an area covering approximately 40,000 acres bounded on the north by the Royal Canal and on the south by the Grand Canal, approximately 2¼ miles wide and 2½ miles long, encompasses the medieval city, the classical city and most of the 19th century expansion. Due to the compactness of the inner city it was decided to concentrate on the area within the canals, with the exception of two significant building complexes outside the city – Radio Telefis Eireann and University College Dublin.

The same compactness made it relatively easy to settle on a chronological structure for the guide as walking tours on an area by area basis would not be particularly useful to a visitor. Most of the buildings listed in the inner city can be visited by a reasonably energetic walker. As the architectural character of Dublin lies as much in its precincts and streetscapes as in an individual building, walking is by far the best way to appreciate the richness of Dublin's architecture.

A complete guide to the buildings of Dublin, even if limited to the inner canal ring, would be a task far beyond the scope of this book, which is a selection of buildings important in or typical of their time.

The guide is divided into four sections: Medieval Dublin, Classical Dublin, Georgian and Victorian Dublin and 20th Century Dublin. Each section is preceded by an introduction on that period. Entries are laid out as follows: name of building, address, name of architect, date of completion. Access details are given, based on information currently available. Right of access is not implied by inclusion.

This guide is a further development of a Map Guide produced by the RIAI to commemorate its 150th Anniversary in 1989 and particular thanks are due to Arthur Gibney and Frederick O'Dwyer for up-dating the classical and Victorian sections. Thanks are also due to Loughlin Kealy, Niall McCullough, Arthur Gibney, Frederick O'Dwyer and Sean Rothery for their introductory essays. The guide could not have been produced without the help of the many architectural practices who provided information and photographs. Particular thanks are due to David Griffin of the Irish Architectural Archive, to the Office of Public Works, to Robert Towers, to Karl Burton who drew the maps and to Catherine Bolster and Carol Curran of the RIAI for their patient typing of the text.

John Graby
Deirdre O'Connor

Dublin's Urban Form

Niall McCullough

Dublin has been marginalized in the history of architecture and urban design – too close to be exotic, too far to be familiar. In common with other non-Roman northern European cities, its urban structure is a complex weave of many cultures which evolved over a long period of time. Its roots lie in Celtic and even prehistoric times. The name in Irish – Baile Atha Cliath – the town of the Hurdle Ford – gives away its origin as a river crossing place which recent research has suggested lay at an important junction of great prehistoric highways crossing Ireland in the centuries BC. Some of these remain embedded in the urban plan. Its immediate geography – in particular a promontory at the junction of the Liffey and the Poddle – made it an attractive and defensible site for Viking settlers who arrived there in 841. Though expelled for a time by local Irish rulers, they returned in the 10th century to found a city state which had its own dynasty, traditions and an important role in the wider Viking world.

Their citadel on the promontory developed into a walled enclosure running along Castle Street to Cornmarket with lanes north to the river and south to the Poddle where a pool – Dubh Linn – provided a safe harbour for boats. Beyond the city walls, the Viking era established the framework of the later city, with churches, lanes and an oval monastic enclosure still visible in the modern street plan. The Normans – who took the city in 1171 and resettled it – accepted its basic structure, adding new walls, streets, suburban monasteries, lanes and land holdings. After 13th century expansion and 15th century decline it entered the Reformation and classical age barely affected by dramatic urban change.

It was only in the period after 1660 that the city began to assume its modern character and importance under the rule of the Viceroy James Duke of Ormonde – a cosmopolitan who had witnessed the splendour of Louis XIV and Versailles. He engendered the concept of Dublin as a capital city for the island of Ireland whose architecture and urban design should reflect its status. This heroic period before 1700 – forgotten in the understanding of Georgian Dublin – was critical to the establishment of the city's structure. Although large public works were initiated – the rebuilding of Dublin Castle, the Royal Hospital Kilmainham and later the port of Dublin (one of the great engineering works of the 18th century), the bulk of new work was

based on private speculative ventures in the production of 'estates' of exclusive houses on small parcels of land. Quays were created along the river with new developments like St Stephen's Green (1666), the Smithfield Estate and the Jervis Estate around Capel Street which included the completion of a new bridge to link new northern suburbs to the old medieval core. The layout of the city was not based on an overall plan, but on the layout of these private developments – each a formal or classical set piece of planning within defined land boundaries which was adjusted to suit neighbouring developments and local conditions of topography and antiquity. Many of the land holdings were based on older patterns of ownership between medieval lanes – therefore conserving many elements of an older plan into the modern street pattern.

Part of the city's character is based on the nature of the buildings of which it comprised. Apart from the famous public buildings, the heart of the city lies in its ordinary houses where reticent northern European façades hide Rococo decoration and ingenious plans – a laboratory of types within the discipline of the plot. Part 'architecture', part building, they were capable of immense transformation and adjustment. One finds a huge variety from the grandest stone houses to houses forming part of a terrace (retaining a sense of distinction by pulling back slightly from the streetline) and the acres of four-storey brick dwellings with distinctive plans maximizing space, light, economy of materials. The model was never static or even purely domestic, often inhabited by alternative functions – banks, bordellos, shops or circulating libraries.

Perhaps the most interesting aspect is the interrelationship between the house and the plan of the city, where the Georgian terrace house – essentially a two-dimensional building type – is called on to make a corner or to form coherent elevations. The answer can still be seen throughout Dublin – blank façades with a line of staircase windows, polygonal or semi-circular bows, astutely planned pairs of houses forming apparently cohesive elevations, one facing forward, the other into the side street. Where land was more valuable, the corner plot was divided into a number of tiny units which present a full Georgian façade to the street but are nothing more than a room and the stairs on each floor.

The other valuable lesson Dublin offers is in the means by which this mass of Georgian houses was adjusted and how interventions were made by neo-classical and Victorian architects. The Wide Streets Commissioners, active between 1757 and 1841, were a public body concerned to open new avenues through existing urban fabric in order to link major public buildings. They gave Dublin what London significantly lacked, an overall 18th century vision which was successful partly because of the city's relatively small size. Their work included site assembly, negotiation, supervision of the design of streets and also the tautly formal blocks of shops/houses that stand along them. They effectively changed the axis of the city: Westmoreland Street and O'Connell Street remain major arteries today and the outline – if not the detail – of the uniform terraces survive throughout the centre, in Dame

Street and Parliament Street. By 1790 private building proposals had to be submitted to the Wide Streets Commissioners as well, an early and effective planning control which ensured that the city did not evolve on a *laissez faire* basis.

Dublin's relative poverty in the 19th century ensured that wholesale Victorian reconstruction did not occur. Rather than tinkering with the fabric, Georgian mansions were turned to Victorian uses. Leinster House in Kildare Street was given four 'wing' museums in a parody of its Palladian origins; theatres and shops were hollowed out of backlots – a topology constantly surprising in its adaptability and still fundamentally relevant to the current practice of intervention.

The Medieval City

Loughlin Kealy

The medieval city of Dublin is not obvious. It remains to be discovered by the intrepid searcher – hidden as it is in the patterns and names of certain streets and lanes and in surviving fragments within buildings that have been overlaid with the patina of later developments. The city has had a long and turbulent history. Before the longphort of the Norsemen was built in 841, there was a fishing village at the ford of Ath Cliath. A number of what one might call 'great roads' converged at or near this location, forming a basic pattern which was to be elaborated by the Norsemen and later by the Normans. It is thought that the Norse settlement was first centred on a headland overlooking the confluence of the Poddle and Liffey rivers, thus providing the location for the harbour or longphort. Typically for a Viking town, the principal streets ran roughly at right angles to the Liffey, with linking routes running parallel to the river.

The settlement gradually adopted a cosmopolitan character, in accordance with its development as a successful commercial port. It became also a Hiberno-Norse town, integrated into the society of the time.

Dublin's emergence as a city was a gradual development, from village to trading post, to fortified settlement to walled town. It is not known when it was first encircled by defensive walls. The evidence of contemporary sources suggests that it was walled when a Hiberno-Norse stronghold, well before the time of the Norman arrival in 1170, and that there were at least two gates in the town wall at that time. While there are documentary references to walls, towers and gates throughout the 13th and 14th centuries, the most substantial description of the city wall dates from much later, the late 16th century, at which time it enclosed an area of about 44 acres, with several gates and over twenty towers or mural castles. Very little of these fortifications now remains: a short stretch parallel to Back Lane near Cornmarket, and St Audeon's Arch on Cook Street, dating from the mid-13th century. The wall adjacent to the Arch lies along the line of the Hiberno-Norse wall, which was built about 1100. It has been altered many times and restored, but no doubt, contains within it much of the original masonry.

The walled city had its suburbs. To the south were a number of early Christian churches with their enclosures, and to the east lay Hoggen Green, where the Viking Thingmote, a mound used for their assembly, was located. This mound lasted until the late-17th

century, when it was levelled to provide fill for the environs of present-day Nassau Street. North of the river, the suburb of Oxmanstown was populated by Vikings; excluded from the city itself, it has been linked by a bridge since about the year 1000.

The key to understanding the layout of the medieval city lies in the pattern of the great roads, overlaid upon the topography of the south bank of the river. A ridge of high ground runs parallel to the River Liffey, at the time a great deal wider than the present channel. This ridge slopes sharply to the river on its north side, and more gently to where the River Poddle joins the Liffey to the east. This river has been fully culverted since the last century, but in medieval times it flowed towards the Liffey from the south until it met the ridge, and then curved around the east end of the ridge through what is now the lower yard of Dublin Castle to join the Liffey. The ridge, higher over the river nowadays due to the accumulation of rubble from centuries of building, formed the focus of the walled town, with its castle located close to the confluence of the two rivers. The main street ran along the top of the ridge, on the line of High Street and Castle Street. Thomas Street to the west and Dame Street to the east lay outside the walls. Cornmarket, its present-day name reflecting its medieval function, lay just inside the western gateway. The main street was crossed by two principal routes: Winetavern Street/Nicholas Street to the west, and Werburgh Street/Fishamble Street to the east. These streets were developments of the original Norse layout. The Normans added a port area, reclaiming land between the foot of the ridge and the shore of the river.

Within the walled area, the dominant buildings of the Castle and Christchurch Cathedral have been altered beyond recognition over the centuries, yet each contains important remains of the early structures.

The Castle was begun in 1204, but took many years to finish. It occupies the south-east corner of the walled enclose of the time, and was roughly rectangular in shape. It had four circular corner towers, with a fifth mid-way along the south wall. Its gateway was to the north, opening into the walled town. Its form is that of a keepless castle, and is similar to a number of other castles of this period in Ireland, notably Limerick and Roscommon, Dublin Castle being of course the most important. Its extent corresponded to the upper yard of today. Much of the medieval castle was destroyed by an accidental fire in 1684. The south-east corner tower, called the Record Tower, still stands. Excavations undertaken as part of the recent refurbishment of the Castle, have exposed the lower part of the north-west corner tower, called the Corke Tower, which had been demolished in the 18th century. The remains are incorporated in the new work and can be seen by visitors to the Castle.

Christchurch Cathedral was founded soon after the year 1038, the year that Sitric, King of Dublin, went on pilgrimage to Rome. On his return, he gave the site for a cathedral to Bishop Donatus (Latin form of Dunan), the first known bishop of Dublin – the bishops being required to take an oath of submission to the English see. The first bishops were Benedictine monks, but for

most of the medieval period the Cathedral was served by monks of the Augustinian order. The foundation was known as the Church of the Holy Trinity. Its crypt is the oldest standing building in the city, dating from the 12th century. The remains of the chapter-house of the canons can still be seen in the grounds of the cathedral to the south. Externally, the cathedral is a creation of the 19th century, but its interior contains important remains of its medieval structure, originally built by English masons from the Severn Valley and Bristol Channel areas. The basic structure of the transepts dates from the 12th century, as do two arches, one arch on either side, which are from the choir of that time. In addition, both north and south transepts and the north choir have carved capitals from this period.

The oldest church site is most likely that of St Audeon's, believed to have been the location of an early Christian church dedicated to St Colm Cille. The tower one sees today dates from the 17th century. Other prominent churches within the medieval wall include that of St Olaf, which was in use until its demolition in the 16th century, St Mary del Dam which gave its name to Dame Street, St Werburgh and St Nicholas.

A significant development in the life of the medieval city was the granting of its charter by Henry II of England in 1171/2. The charter was in effect, a granting of the town to Henry's followers from the city of Bristol. Not only did Dublin acquire a legal structure and administration modelled on that city, but very many of its inhabitants were forced to re-locate outside the town walls, a repeat of the experience of its earlier Viking inhabitants. This charter also confirmed certain individuals and establishments outside the walls in their pre-existing rights and privileges, thereby exempting them from the controls imposed on the citizens of the city. These were termed 'Liberties' – the origin of the name still given to the area to the south-west of the medieval city.

Characteristic of the Norman period was the existence of a number of outlying religious foundations. Principal of these were the Abbey of St Thomas the Martyr (founded in 1177) to the west, St Patrick's (consecrated in 1192) to the south, All Saints' Priory (founded in 1166) to the east on the site of the present-day Trinity College, and across the river to the north, St Michan's (1098) and St Mary's Abbey (established in 948) at the edge of the Viking suburb of Oxmanstown. Of these the most important was that of St Patrick's, located at a site traditionally associated with that saint. Its holy well, associated with an earlier church, continued in use until the 16th century.

The cathedral was built first by John Comyn, a Benedictine monk and close associate of Henry II. Comyn, who had been sent to Ireland to increase the control of the crown over the Irish Church, upgraded the church to the status of cathedral. Reluctant to remain within the walls, where he would have had to contend with the city authorities, he built the church and his palace nearby. The palace was known as St Sepulchre's, and survives today in a transformed state as the police station on Kevin Street. Comyn's successor, Henry de Loundres, created a new charter for the cathedral, establishing offices and the Deanship, and rebuilt the structure in a form which survives, though modified many times, to

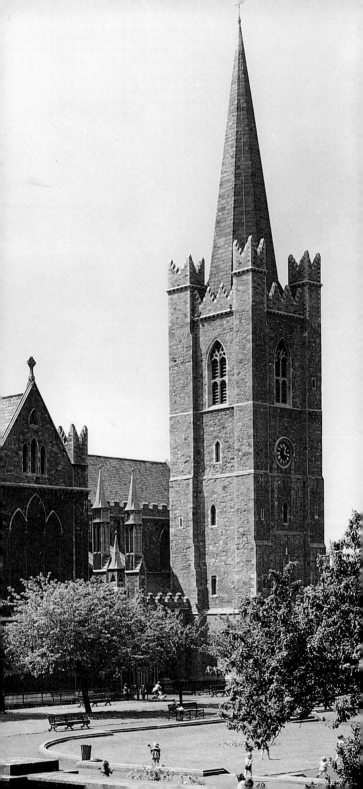

this day. The cathedral was rededicated in 1254, and the Lady Chapel added in 1270. When first built, the cathedral stood within its own walled enclosure. The tower of the cathedral was destroyed in a fire in 1362, and was re-built about 1370. The lower section of today's tower is of this date, the spire being much later and dating from 1749. It was built to a design by George Semple. The cathedral itself was repaired in 1555 and suffered at the hands of the Cromwellians in 1660. It was repaired several times during the 19th century: in 1850 by Dean Pakenham, and in 1860 and 1864 by Benjamin Guinness. The choir and stone roof were restored by Lord Iveagh between 1901 and 1904.

The 13th century and the first half of the 14th were times of prosperity and expansion for the city. This period saw the construction of public and semi-public buildings within the walls. Prominent among them was the Tholsel, the courthouse and merchant's headquarters. This was located at the corner of Skinner's Row (Christchurch Place) and Nicholas Street. The city also developed specialized quarters devoted to particular activities: leather-workers in the High Street/Skinner's Row area, wood-turners and coopers in the upper part of Winetavern Street, makers of iron goods in Castle Street, and of course the fish market in Fishamble Street. The latter half of the 14th century saw the city in decline, with the energies and resources of the townsfolk increasingly affected by the need to resist the onslaughts of the 'Irish'. It has been observed that, in contrast to the Hiberno-Norse period, in Anglo-Norman times the native Irish were excluded from active participation in the economic and political life of the city.

The onset of the Reformation in the 16th century, and the consolidation of the power of the Tudor monarchy in Ireland mark the transition from medieval to modern times. It was marked by the acquisition by the crown of substantial lands and properties formerly held by the Church, and polarized the population of the city into patterns of loyalty and religious allegiance that were to persist through the later developments of the city in the 17th and 18th centuries. The 16th century saw the consolidation of the urban structure, with streets densely lined with houses, backlands filled in and an expansion of its suburbs.

1
City walls
Cook Street, Dublin 8

Some sections of the medieval walls can still be seen, notably in
Ship Street. The most substantial remaining section is the inner
wall, c.1240, in Cook Street. Saint Audeon's Arch was completed
in 1275 and restored by Dublin Corporation in 1975. The city walls
extended to the River Liffey on the north, to Parliament Street on
the east, to Saint Augustine Street on the west and to the line of
the Bermingham Tower of Dublin Castle to the south.

2
Saint Audeon's
Cook Street, Dublin 8
Architect: unknown
Access: Mon–Fri 9.30am–5pm

The church is dedicated to the Norman saint, Saint Audeon of
Rouen. The earliest section is the west doorway, c.1200; the nave
is early 13th century and the tower is largely 17th century. The
original chancel is now un-roofed. Saint Audeon's, the restored
city walls and the neo-classical church of Saint Andrew's in High
Street, form an attractive group.

3
Dublin Castle
Dame Street, Dublin 2
1204
Architect: unknown
Access: Mon–Fri 10am–12.15pm and 2pm–5pm;
Sat–Sun 2pm–5pm

The building of Dublin Castle was authorized by King John in 1204
and for 700 years was the seat of the English administrative
system. The medieval castle was built on the site of the previous
Viking fort. The Upper Yard of the present day complex
corresponds to the area of the medieval castle. The 14th century
Bermingham Tower can still be seen. In 1988 sections of the wall
and moat were uncovered during restoration works and can be
visited. (See also entry number 24.)

4
Christchurch Cathedral
Christchurch Place, Dublin 6
1038
Architect: unknown
Access: Mon–Sun 10.00am–5.00pm

Christchurch Cathedral stands at the centre of the medieval city of
Dublin. Founded by Dunan, first Bishop of Dublin in 1038, it was
built originally as a timber structure. Following the Norman invasion
in the 12th century, a stone cathedral in Romanesque style was
erected on the site. Only fragments of the 12th and 13th century
structure are still in existence notably the crypts and the north and
south transepts. By the mid-19th century the cathedral had fallen
into a poor state of repair and had a basic weakness in that the
walls of the nave were too thin to take the weight of the stone roof.

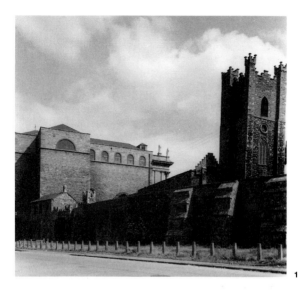

1

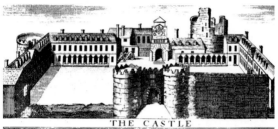

THE CASTLE

3

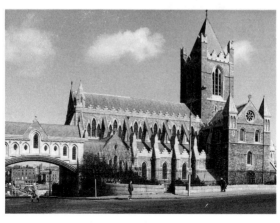

4

The south wall had collapsed in 1652 and been badly rebuilt. Between 1871 and 1878 the entire building was 'restored' by the architect George Edmund Street. Whole sections of the cathedral were rebuilt in Gothic Revival style. The building as it presently exists, is largely the work of Street. In the 1980s it was again the subject of restoration. G.E. Street also designed the adjoining Synod Hall and the attractive linking bridge. The Synod Hall is presently being refurbished (1992) by Murray O'Laoire Architects as an exhibition centre for medieval Dublin.

5
Saint Patrick's Cathedral
Patrick Street, Dublin 8
Architect: unknown
Access: Mon–Fri 9am–6pm; Sat 9am–5pm; Sun 10am–11am and 12.30pm–3pm
Built between 1220 and 1254, Saint Patrick's is the largest Irish cathedral church and stands on the site of a pre-Norman parish church. The cathedral was damaged by fire in 1362 and large sections were subsequently rebuilt under the directions of Archbishop Thomas Minot who also built the stone tower at the western end of the north wall. The choir is the best preserved section of the medieval fabric. The present cathedral is largely the result of rebuilding carried out from 1864 onwards by Sir Thomas Drew, Architect, under the patronage of Sir Benjamin Lee Guinness. The cathedral's most famous incumbent, Dean Swift, is buried in the south aisle of the nave, alongside 'Stella'.

6
Saint Mary's Abbey
Mary's Lane, Dublin 1
1139
Architect: unknown
Access: exteriors only and during church services
Founded in 1139 by the Cistercians, this was one of the largest monastic buildings of medieval Ireland. The Chapter House and a passage to the south of it are all that remain of the great Abbey: nothing survives of the church. The Chapter House is a fine vaulted room dating to about 1190, although it and the south passage have been partially rebuilt. The site is presently surrounded by warehouses. It was in the Chapter House that the Lord Deputy, 'Silken Thomas', begun the insurrection of 1534.

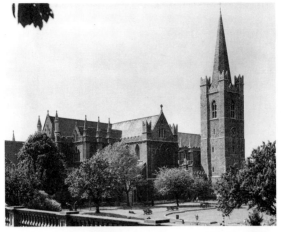

5

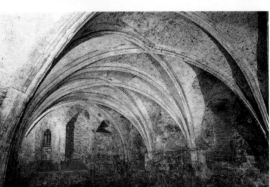

6

The Classical City

Arthur Gibney

The 18th century was a golden age in Ireland. Continuous peace after centuries of war encouraged agriculture, industry and cultural development. Dublin the capital city, increased its population from 62,000 in 1700 to 180,000 inhabitants at the end of the century. Its combination of parliamentary seat, financial centre, major port and focus of trade and industry gave it advantages over every city in the British Isles except London, which it saw as a rival in the pursuit of power and wealth.

The Palladian movement, which had started in England under the patronage of the Earl of Burlington began to influence Irish architecture from the late-1720s. The first fruits of this influence can be seen in the Parliament House built in 1730 as an expression of colonial independence and designed by the most talented architect of the early 18th century, Edward Lovett Pearce. Pearce's colonnaded loggia surrounding the former public forecourt and entrance to the House of Commons is one of the most perfect architectural expressions in western Europe and it still survives as part of the Bank of Ireland complex on the southern side of College Green. The flanking quadrants and much of the interior are later 18th century additions, but James Gandon's corinthian hextastyler portico to the House of Lords (1780) makes an impressive neo-classical statement on the eastern façade and recalls the restrained eloquence of Souflot's St Genevieve.

After Pearce's death in 1733 architecture in Dublin was dominated by the confident professionalism of Richard Cassels, who consolidated the Palladian style in a series of public buildings and urban houses. His most visible works are Leinster House, built for the Fitzgerald family and now the seat of the Irish Parliament, the Rotunda Hospital, Clanwilliam House and its adjoining neighbour number 86 St Stephen's Green which were both restored by University College Dublin and opened to the public.

The mid-century also saw the formation of two of Dublin's most important classical precincts at Trinity College and Dublin Castle. Trinity College founded in 1693 by Queen Elizabeth I, had outgrown its 17th century roots and ranges of new buildings enclosing a series of quadrangles were begun in the 1750s, including Regent House, facing on to College Green, the Dining Hall, Chapel and Theatre (both designed by Sir William Chambers), and the Provost's House, which is the only 18th century mansion in Dublin remaining in continuous use as a dwelling.

The classical remodelling of the medieval buildings of Dublin Castle, which was the seat and symbol of English power in Ireland, was started early in the century and extended by the building of the elegant terraces of the Upper Castle Yard dating from the 1750s. An extensive rebuilding programme, carried out by the Office of Public Works in the 1980s, included the restoration of the Gate of Justice and the Bedford Tower and a refurbishment of the north and west ranges as a conference centre.

The formation of Dublin's renowned Georgian squares with their continuous terraces of urban row houses began in the early 1760s, although the four-storey house type with its classical doorcase and fenestration had been in common use in Dublin since the 1730s. Merrion Square, Fitzwilliam Square and the adjoining streets, from Mount Street to Hatch Street, form a distinctly classical precinct on the southside of the river. Mountjoy Square and Parnell Square form the nucleus of a similar precinct on the northside, but the houses here, like many in the terraces of the adjoining streets, have suffered badly from neglect and dereliction.

The last two decades of the century were dominated by the considerable talents of James Gandon, who was responsible for Dublin's two great riverine monuments, the Custom House (1780s) and the Four Courts (1790s). Both are sited on the north bank of the Liffey and both make elegant use of the well-founded local formula of white Portland stone and silver grey Dublin granite. The Custom House was recently restored to mark the anniversary of its bicentenary.

7
Royal Hospital
Kilmainham, Dublin 8
1680
Architect: Sir William Robinson
Access: Mon–Sat 10am–5.30pm; Sun 12pm–5.30pm
The first great classical building in Ireland and the first by a single named architect. Built by James Butler, the great Duke of Ormonde, as a home for retired soldiers on the model of Les Invalides in Paris, it is a large quadrangular building with limestone arcades at ground level in the courtyard. Limestone details at doorcases, string courses and entablature, together with simple stucco window surrounds give interest to the rough plastered walls. A limestone gothic gateway designed by Francis Johnston stands at the west entry into the Royal Hospital Kilmainham grounds, having been moved there in 1846 from its original position on the Liffey quays. The restoration by John Costello (consultant to the Office of Public Works, principal architect M.D. Burke) of Costello Murray and Beaumont, architects, was completed in 1985. The Royal Hospital Kilmainham is now the home of the Irish Museum of Modern Art. The conversion of part of the interior to this use was carried out by Shay Cleary in 1991.

8
Saint Michan's
Church Street, Dublin 7
1683–86
Architect: unknown
Access: Mon–Fri 10am–12.45pm and 2pm–4.45pm;
Sun 10am–12.45pm only
Dedicated to Saint Michan in 1095, for 600 years this was the only parish church north of the river. It was rebuilt in 1683–86, but the interior dates from c.1810. Built of rubble masonry, calp limestone, its distinctive crenelated tower is a landmark on the Dublin skyline. The finely carved organ in the entrance hall is said to have been played by Handel at the first performance of the 'Messiah'. Edmund Burke, the great orator, was baptised here. Mummified bodies can be seen in the vaults, whose 17th century structure would seem to contradict the antiquity claimed for these corpses.

9
Saint Mary's Church
Mary Street, Dublin 1
c.1700
Architect: Thomas Burgh
Access: exterior only
An early classical church, its interior has many interesting features, including a handsome carved organ case by Renatus Harris. It was probably the first galleried church to be built in the city. The mouldings on the east window add interest to its austere stone façades. Wolfe Tone was baptised here and John Wesley preached his first sermon in Ireland at Saint Mary's. Now deconsecrated the future of St Mary's is in doubt and interior fittings have been stolen.

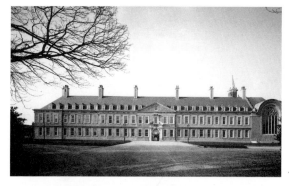

7

8

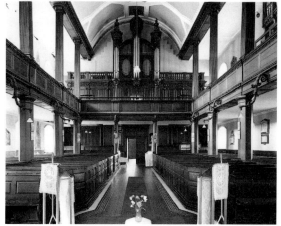

9

10
Marsh's Library
Saint Patrick's Close, Dublin 8
1705
Architect: Sir William Robinson
Access: Mon, Weds, Thurs and Fri 10.00am–12.45pm and
2.00pm–5.00pm; Sun 10.30am–12.45pm. Closed all day Tues
Built to house the Library of Archbishop Narcissus Marsh, this is a
two-storey, L-shaped building adjoining Saint Patrick's Cathedral
and graveyard. The original brick facing was replaced in the 19th
century with a mixture of stone and brick: the Gothic-style
entrance and battlements also date from that period. The interior
remains unaltered with dark oak bookcases arranged in bays
between the windows. In 1988, a small brick-faced Bindery was
incorporated into the Library gardens by Arthur Gibney & Partners,
architects.

11
Taylors Hall
Back Lane, Dublin 8
c.1706
Architect: attributed to Richard Mills
Access: Mon–Fri 10.00am–4.00pm
Tailors Hall is the last remaining Guildhall in Dublin, dating from the
reign of Queen Anne. Entrance is through a pedimented stone
gateway into an attractive courtyard. The hall proper, with its four
tall arched windows, was traditionally available for hire in the early
part of the 18th century and was the largest public room in Dublin.
In 1792 it was let to the United Irishmen under Wolfe Tone and
nicknamed the Back Lane Parliament. It was restored in the 1970s
by Austin Dunphy, architect, and is the headquarters of An Taisce,
the National Trust for Ireland.

12
Mansion House
Dawson Street, Dublin 2
1710
Architect: unknown
Access: exterior only
The Mansion has been used as the Lord Mayor's residence since
1715. The original two-storey building was faced in brickwork but
its front façade was redesigned with Victorian stucco and cast-iron
embellishments by the then City Architect Hugh Byrne in c.1851. A
cast-iron porch, designed by D.J. Freeman, was added in 1886.
Internally, the panelled hall and staircase have remained largely
unaltered since 1710, although the Oak Room of 1715 has been
much altered. The Lord Mayor's Residence in Dublin predates its
London counterpart by almost twenty years.

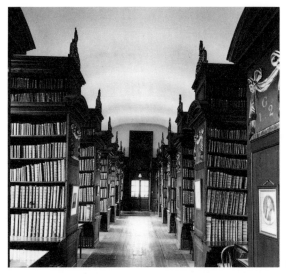

10

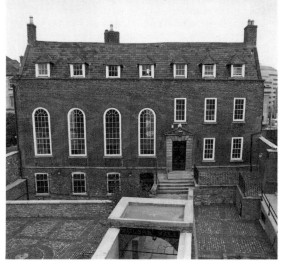

11

13
Saint Werburgh's
Werburgh Street, Dublin 8
1715
Architect: attributed to Thomas Burgh
Access: Sunday morning 12.00pm or by appointment
All that now remains of Burgh's work is the structure, including the heavily moulded baroque façade. The interior of the church dates from 1759 and was designed by John Smyth. The original baroque spire was removed in the 19th century probably to eliminate such an excellent vantage point overlooking Upper Castle Yard. The crypt contains the remains of Lord Edward Fitzgerald and of Mayor Sirr, who inflicted the wounds of which Fitzgerald ultimately died.

14
Dr Steeven's
Steeven's Lane, Dublin 8
1720
Architect: Thomas Burgh
Access: by application only
Dr Steeven's was the oldest private hospital in Ireland and one of the oldest in the British Isles. It was similar in plan form to the Royal Hospital Kilmainham, with an arcaded courtyard, steeply pitched roof and dormer windows. Edward Lovett Pearce acted as superintendent to the work after Burgh's death. The Worth Library is the most significant part of the interior. It was probably designed by Hugh Wilson, the master carpenter who executed the work. The hospital was in everyday use until the 1980s and was greatly altered and extended over its long history. Bought by the Eastern Health Board to act as its headquarters, the building has recently been extensively restored and converted by Arthur Gibney & Partners, architects. The area to the north side of the building has been redesigned to form a new urban plaza.

15
Saint Ann's Church
Dawson Street, Dublin 2
1720
Architect: Isaac Wills
Access: Mon–Fri 10.00am–2.00pm
Originally designed in a baroque style which was diluted before it reached fruition, the building was altered in 1868 by Sir Thomas Newenham Deane, architect, who added the polychromatic Romanesque façade to Dawson Street. The bell tower which he also proposed remains uncompleted. The interior is a galleried space, 'one of the noblest church interiors in Dublin'. There are many good monuments: a plaque in the church commemorates Felicia Hemans the author of the famous poem beginning 'The boy stood on the burning deck...'.

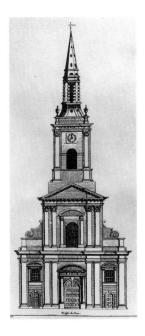

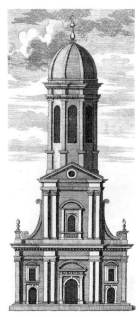

13

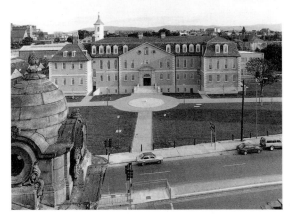

14

16

Old Parliament House/Bank of Ireland

College Green, Dublin 2
1729 and 1785
Architects: Edward Lovett Pearce – 1729;
James Gandon – 1785
Access: Mon, Tues, Weds and Fri 10.00am–3.00pm;
Thurs 10.00am– 5pm

The Parliament House was built to accommodate the Irish Houses
of Commons and Lords, in a style more magnificent and more
obviously democratic than its counterpart in London. It was a
tangible expression of Irish colonial independence. The Palladian
centre block was designed in 1729 by Sir Edward Lovett Pearce
with temple, portico and flanking colonnaded wings. The
magnificent Corinthian portico to the east is by James Gandon,
c.1785, and the western Ionic portico is by Richard Parkes. The
building displays the first use of what became a highly successful
formula used in public edifices throughout Dublin in the 18th and
19th centuries – the combined use of imported Portland stone
dressing with native Dublin granite masonry. The plan of the
Parliament House was innovative and successful, and influenced
future buildings such as Smirke's 19th century British Museum.
Grattan's Parliament sat here until abolished by the Act of Union. In
1803, after Parliament's dissolution, the building was taken over by
the Bank of Ireland. It was remodelled by Francis Johnston,
architect, who designed the Cash Office, in 1803.

17

Henrietta Street

Dublin 1

Henrietta Street was the first major development by the Gardiner
(Mountjoy) family whose estate ultimately covered much of the
north-eastern perimeter of the 18th century city. It contains two
terraces of the largest and grandest of the Dublin classical town
houses; some are now in poor condition. The Street was built by
Luke Gardiner (1730–1740) and his own house, number 10
(Mountjoy House), and numbers 9 and 11 have been attributed to
Edward Lovett Pearce, the architect of the Parliament House in
College Green. The design of these houses was strongly
influenced by the plan and section of the houses developed by
Lord Burlington (Old Burlington Street) in London. Numbers 3 to 7
were designed by Nathaniel Clements, architect, who lived himself
in number 7 from 1733 until his death in 1777. The 18th century
occupants of the other houses reflected the importance of the
street as the most fashionable address in Dublin. Numbers 5 and 6
(originally a single dwelling) housed at various times, the Earl of
Thomond, the Earl of Bessborough, the Bishop of Ferns, the
Bishop of Limerick and the Speaker of the House of Commons.
Number 9 contains one of the finest stairhalls in Ireland and
permission to see it, and the ground floor of number 10, can be
obtained from the Sisters of Charity who occupy both houses. The
19th century law-library of the King's Inns on the south side of the
street occupies the site of a mansion built by Luke Gardiner in
1730 for the Lord Primate and Archbishop of Armagh.

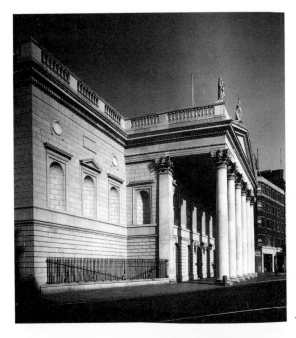

16

17

18
Iveagh House
80/81 St Stephen's Green, Dublin 2
1730
Architect: Richard Cassels
Access: exterior only

The house at No. 80 St Stephen's Green was the first of Cassels' notable Dublin houses. It has been greatly altered and only the first floor saloon remains of the Cassels' design. In the 1870s, Sir Benjamin Guinness linked Numbers 80 and 81 and refaced them to appear as one house. Sir Arthur Guinness, his son, was responsible for the opening of St Stephen's Green to the public. Sir Benjamin's grandson, the 2nd Earl of Iveagh, presented the house to the Irish Government and it now accommodates the Department of Foreign Affairs.

19
Clanwilliam House
85 St Stephen's Green, Dublin 2
1738
Architect: Richard Cassels
Access: Tues–Fri 10.00am–4.30pm; Sat 2.00pm–4.40pm; Sun 11.00am–2pm (1 June – 30 September only)

This building is reputed to be the first stone-faced house on St Stephen's Green. It is notable for its fine interiors and elaborate plasterwork by the Francini brothers, particularly in the first floor saloon. The house was built for entertaining rather than living and is composed almost entirely of reception rooms. The building now forms part of Newman House, University College Dublin. It is largely intact and is presently the subject of an on-going restoration programme led by architects Sheehan and Barry.

20
Tyrone House
Marlborough Street, Dublin 1
1740
Architect: Richard Cassels
Access: Mon–Fri 9.00am–6.00pm

Cassels' great contribution to Dublin's architecture was the building for the nobility of great town houses in cut stone. The first of these, in simple Palladian style, was Tyrone House built for Sir Marcus Beresford. The façade has been greatly altered; the original doorcase and venetian window have gone. The building is now chiefly notable for its fine interior with Rococo ceilings by the Francini brothers. The house was taken over in 1835 by the Board of National Education, and was later made part of an elaborate symmetrical layout around a central lawn fronting the Central Model School. The whole complex is occupied today by the Department of Education.

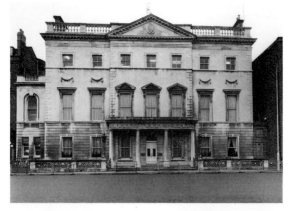

18

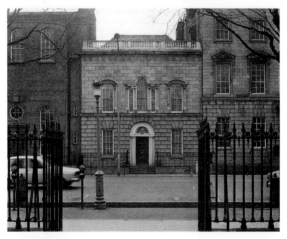

19

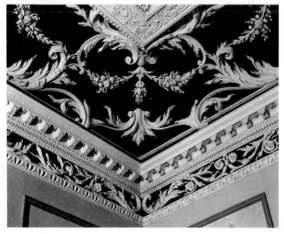

20

21
Leinster House
Kildare Street, Dublin 2
1745
Architect: Richard Cassels
Access: by appointment only

The largest of Cassels' town houses, Leinster House was designed in the style of a country house with two façades of equal importance. Originally called Kildare House after James Fitzgerald, 20th Earl of Kildare, for whom it was built, it was later known as Leinster House when James became Duke of Leinster. The west front was built in Ardbracken limestone. The building itself has altered little apart from some remodelling by James Wyatt and the inclusion of some ceilings by Sir William Chambers. Following the Act of Union, Leinster House was occupied by the Dublin Society now the Royal Dublin Society. Under its aegis, it became the centre of a complex of cultural institutions, the Museums, National Gallery and National Library, all of which are still in existence. From 1921, until the present day Leinster House has been the seat of Dail Eireann, the Irish Parliament.

22
Rotunda Hospital
Parnell Street, Dublin 1
Architect: Richard Cassels
Access: by appointment only

The Rotonda was the first maternity hospital in Britain and Ireland, founded by Dr Bartholomew Mosse in 1748. It contains a magnificent baroque chapel with superb plasterwork by Barthelemy Cramillion. The adjoining Assembly Rooms (now a theatre and a cinema) include a rotunda designed by John Ensor, architect, in 1764 with later porches by Richard Johnston, architect (1784) and James Gandon, architect (1786). The Pillar Room was restored in 1987 by Dermot Brady of Brady Stanley O'Connell, architects.

23
Saint Patrick's Hospital
James Street, Dublin 8
1749
Architect: George Semple
Access: by application only

St Patrick's, the first asylum built for the mentally ill in Ireland, was founded on the proceeds of the will of the legendary Dean Jonathan Swift, who died in 1745. Swift, who was a governor of the infamous Bedlam Asylum in London, was conscious of his growing insanity which badly incapacitated him in the last few years of his life. The hospital was designed by George Semple, the first of a famous Dublin family of architects, masons, bricklayers and plasterers, who is better known for his treatise on bridge-building called 'The Art of Building in Water'. The building was started in 1749 on grounds belonging to Dr Steeven's Hospital, and the Ashlar façade with its central pediment is faced with grey Kilgobbin granite. Two symmetrical wings were added in 1778 by the neo-classic architect Thomas Cooley.

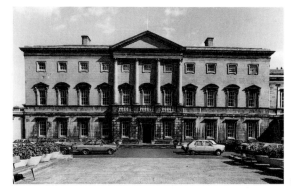

21

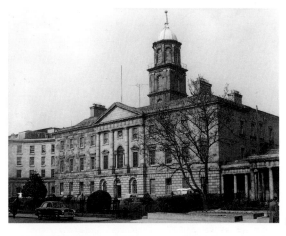

22

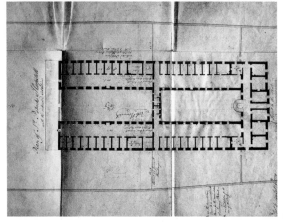

23

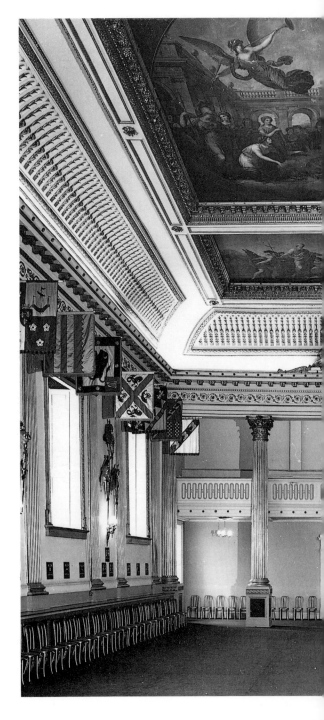

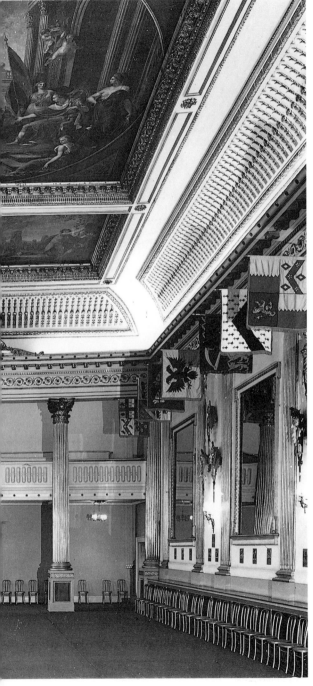

24

24
Dublin Castle
Dame Street, Dublin 2
Access: Mon–Fri 10.00am–5.00pm;
Sat and Sun 2.00pm–5.00pm

The castle is an important 18th century architectural precinct arranged around two quadrangular yards. The south range of the Upper Yard contains the State Apartments which date from a 1685 design of Sir William Robinson, with later alterations by Joseph Jarret c.1750. Oscar Richardson, architect, Office of Public Works, was awarded the RIAI Conservation Medal 1946–77, for the restoration of the State Apartments (a). The north range contains the central Bedford Tower Block (b) with pedimented first floor loggia, and a tall octagonal tower flanked by two powerful baroque gateways and lead statuary by Van Nost, c.1750. The Lower Yard contains the medieval Record Tower and a Gothic Revival chapel by Francis Johnston (1807), the Chapel Royal (c) restored by D. Wall and J. Cahill, Office of Public Works. All the buildings have been rebuilt or restored; the east cross block has been rebuilt in replica and the western and northern ranges were recently reconstructed (1988) by Michael O'Doherty and K. Unger, Office of Public Works. They are also responsible for the construction of the new Conference Facilities to house EC meetings. (See also entry number 3.)

25
Trinity College
College Green, Dublin 2
Access: Mon–Sat 9.30am–5.00pm;
Sun 12.00pm–4.00pm

Dublin University has been described as the most perfect ensemble of 18th century collegiate buildings in Britain or Ireland. The earliest surviving buildings, the Rubrics (a), date from 1700. The Old Library (b) dates from 1712 and was designed by Thomas Burgh; later additions were a staircase hall by Richard Cassels and a magnificent 19th century barrel-vaulted ceiling by Deane and Woodward: the ground-floor area, known as the Colonnades, has recently been refurbished and converted (1992) by Arthur Gibney & Partners and houses the Book of Kells. Cassels was also responsible for the temple-like Printing House (c), 1734, and the pedimented Dining Hall (d), 1745. The Dining Hall was restored by McDonnell & Dixon and de Blacam and Meagher, following a fire, in 1986. The Palladian west front with Rococo garlands over Venetian windows was designed by the London amateur architect, Theodore Jacobsen, in 1752. The Provost's House (e), with Palladian façade derived from Lord Burlington, has a magnificent early 18th century interior and a large salon with a coffered ceiling. The twin buildings on the front quadrangle with Corinthian porticos are the Chapel (f) and Theatre (g) designed by Sir William Chambers, architect, in 1774. (See entries 68, 69 and 70.)

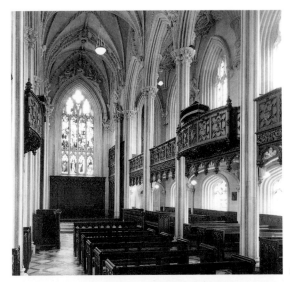

24

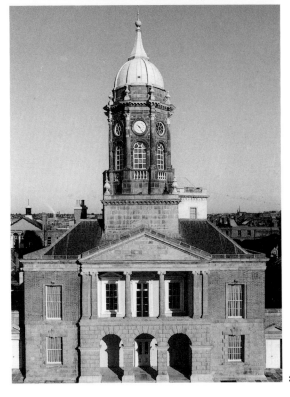

24

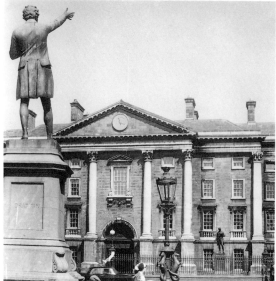

25

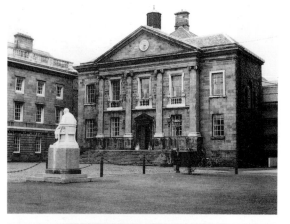

25d

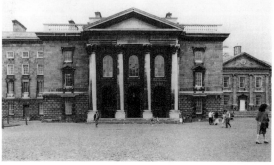

25f

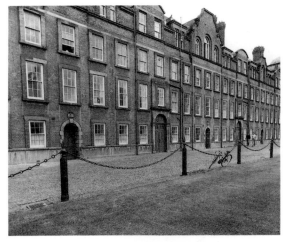

25a

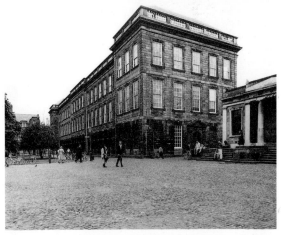

25b

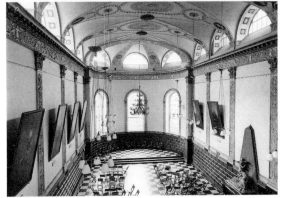

25g

26

Parnell Square

Dublin 1

Parnell Square, formerly called Rutland Square, was the first of the classical squares to be built after St Stephen's Green. It was developed by Luke Gardiner who built Henrietta Street and Sackville Mall (now O'Connell Street) and whose descendants were responsible for later developments such as Gardiner Street and Mountjoy Square. It was partly developed in partnership with Dr Bartholomew Mosse, the founder of the adjoining Rotunda Maternity Hospital. The earlier houses on the east side, dating from 1753, are good examples of the mid-century town house. The design of numbers 10 and 11 are a reworking of the Henrietta Street format based on the model taken from Old Burlington Street, London. These houses (now five-bays wide) were originally built as four-bay houses and extended in the later part of the 18th century. Both have double-height entrance halls and dual staircases, as has number 4. John Ensor, who acted as Richard Cassels' assistant in Trinity College and on the Rotunda Hospital, was involved in the development, and presumably in the design of numbers 5 and 6. The north and west sides of the square were developed in the 1760s and 1770s. Numbers 19 and 20 were renovated in 1991 by Desmond Rea O'Kelly, architect. Number 20, which is open to the public is now the Dublin Writer's Museum.

27

The Casino

Marino, Dublin 3 (Bus No. 24)
1758
Access: Mon–Fri 9.30am–6.30pm

The Casino is an elegant Roman-Doric temple, built as a pleasure house for James Caulfield, 1st Earl of Charlemont, on his demesne at Marino. It is described by Maurice Craig, as 'one of the most beautiful buildings of its kind anywhere'. In this tiny stone building, Sir William Chambers introduced the sophistication of French neo-classicism into Ireland. Externally, the building appears to contain only one room, but in fact its compact and clever plan conceals eight rooms, a staircase and an extensive basement. In 1980, the building was restored on behalf of the Office of Public Works by Austin Dunphy and John Redmill of O'Neill Flanagan, architects.

28

20 Lower Dominick Street

1758
Architect: Robert West
Access: on application only

The house was built by Robert West, Ireland's best known stone stuccodore, for his own use but was almost immediately let to John Beresford. It is an impressive four-bay house, although the exterior is marred by modern windows, with a large entrance hall. There is superb Rococo plasterwork by West in the main rooms. The staircase hall is particularly noteworthy with both wall and ceiling plasterwork in the highest possible relief. The hall has fine examples of West's characteristic birds.

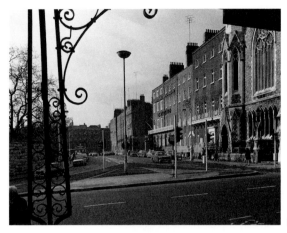

26

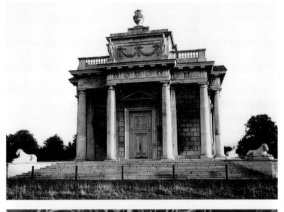

27

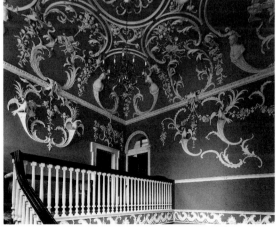

28

29
Charlemont House

Parnell Square, Dublin 1
*c.*1762
Architect: Sir William Chambers
Access: Tues–Fri 9.30am–6 pm; Sat 9.30am–5pm;
Sun 11am–5pm

This was the townhouse of Lord Charlemont, who was known as the 'Volunteer Earl' because of his involvement in the Volunteer movement. The limestone façade remains unaltered but the entrance hall, upper rooms and main staircase are all that remain of the neo-classic interior, which has been extensively altered. The building is now the Municipal Gallery and contains the Sir Hugh Lane collection. Charlemont House is the centre-piece of Parnell Square North.

30
Merrion Square

Dublin 2

In the late-18th century the fashionable elite of Dublin moved slowly from the north to the south of the Liffey and particularly to the area around Merrion Square. The lead in this process was taken by the Earl of Kildare in the construction of Kildare (now Leinster) House in 1745 (see entry number 21). In 1762 Viscount Fitzwilliam commissioned the architect John Ensor, who had planned Parnell Square, to lay out the lands east of Merrion Street. Development of the new square began on the north side, following the usual process of providing 99-year leases for plots of land on which houses were to be built. Small builders took two or three plots each, constructed houses and sold or sub-let the developed plots to visitors or residents. This process gave a variety to the square, and indeed to the whole of Georgian Dublin. The older parts of the square (the north and east side) have a remarkable variety of architectural expression. The headquarters of the Royal Institute of the Architects of Ireland is at 8 Merrion Square North *c.*1766, and the Irish Architectural Archive is at 73 Merrion Square South. In addition to the variety of expression in Merrion Square, which is characterized by differences in heights and widths of the houses and the variety of detail in doors and door casings, the characteristic Dublin Georgian fenestration technique of the 'patent reveal' can be seen to particular advantage in these long terraces. The 'patent reveal' is a plaster lining, usually painted white, around the windows, projecting about 75mm beyond the face of the brickwork which reflects the light and contrasts beautifully with the brickwork. Merrion Square remained largely residential until the 1940s when offices for professionals such as doctors, lawyers and architects began to predominate. This combination of professional and small-scale commercial use was an important factor in maintaining the square in reasonable condition particularly in the absence of any state support for conservation. Recent tax incentives for development in 'designated' areas have resulted in Georgian offices becoming less attractive commercially and puts the future preservation of such an important part of Dublin's architectural heritage at some risk.

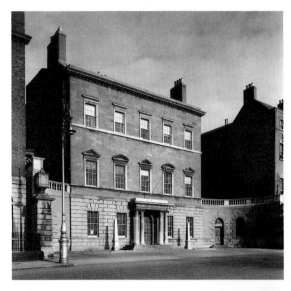

29

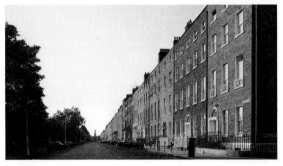

30

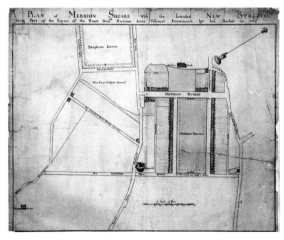

30

45

31
86 St Stephen's Green
Dublin 2
1765
Architect: unknown
Access: Tues–Fri 10.00am–4.30pm; Sat 2pm–4pm;
Sun 1pm–2pm

The building consists of a handsome five-bay façade with a lion couchant over the door. The interior plasterwork by Robert West is of exceptional quality. The house was built for Richard Chapell Whalley MP, who was nicknamed 'burn chapel' for his enthusiastic 'priest-hunting'. His son, the Buck Whalley, is famous for his wager to walk to Jerusalem in 1788. In 1853 the house was bought by Cardinal Cullen for the Catholic University of Ireland founded by John Henry Newman. Gerald Manly Hopkins was appointed to the chair of Greek and Latin at the University in 1884 and spent five years of 'exalted misery' in Dublin until his death in 1889. The house is now owned by University College Dublin.

32
Royal Exchange
Cork Hill, Dublin 2
1769
Architect: Thomas Cooley
Access: office hours

The Royal Exchange was built as the result of an architectural competition and has an impressive neo-classical temple front with giant Corinthian columns and central domed rotunda. Since 1852 it has served as the City Hall and administrative centre of Dublin Corporation. Despite some unfortunate accretions it remains one of the finest 18th century interiors in the city.

33
Saint Catherine's Church
Thomas Street, Dublin 8
1769
Architect: John Smyth
Access: exterior only

This church has a strongly composed façade in Roman Doric style. As is the case with many Dublin churches, the tower was not completed. The façade and the stonework were cleaned by Dublin Corporation in 1975. The church has been deconsecrated and its future is uncertain.

34
North Great George's Street
Dublin 1
Developed by the Archdall family in the 1770s the street is terminated by Belvedere House (entry number 41) to the north. The street contains fine houses; numbers 19, 41 and 42 have intact interiors; numbers 37, 38, 39 have plasterwork by Charles Thorp. After years of neglect many of the houses are now in private ownership and under restoration. Number 35, built in 1784 and first occupied by the Earl of Kenmare, is currently being converted

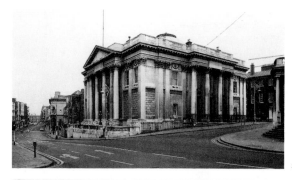

32

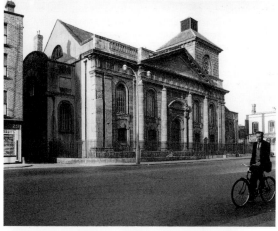

33

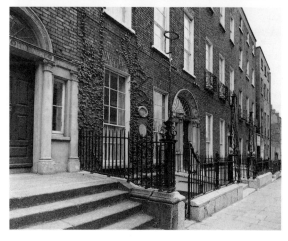

34

by J. O'Connor, architect, as the James Joyce Cultural Centre. The house has fine plasterwork by Thorp and Stapleton and can be visited on application. It was in this house that Mr Maginn opened a dancing academy and advertised himself as 'Mr Denis J. Maginni, Professor of Dancing' and it is under this title that he appears in *Ulysses*.

35
Royal Irish Academy of Music
36 Westland Row, Dublin 2
1771
Architect: unknown
Access: Mon–Fri 9.30am–5.30pm

A fine four-bay mansion with a rusticated ground floor and powerful cornice, the building is in marked contrast to its more modest neighbours. There are fine interiors with delicate plasterwork attributed to Michael Stapleton and extensive and unusual pewter architrave mouldings of particular delicacy. The first-floor rooms have ceiling medallions in the manner of Angelica Kaufmann grisaille medallions by Peter de Gree and Bossi fireplaces. In the 19th century the rear drawing room was gothicized and has an unusual Gothic fireplace.

36
Powerscourt House
South William Street, Dublin 2
1771
Architect: Robert Mack
Access: shopping hours

A powerful composition, with a strongly rusticated base, surmounted by a blind attic and consoles, Powerscourt House was built as a town-house for the third Viscount Powerscourt. The plasterwork in the hall and staircase is by James McCullagh while the first-floor reception rooms are by Michael Stapleton; one room has an unusually shallow domed ceiling. There is a fine carved staircase by Ignatius McDonagh. In 1981 Powerscourt House was converted into a shopping precinct by James Tuomey of Power Securities Ltd.

37
Bluecoat School
Blackhall Place, Dublin 7
1773
Architect: Thomas Ivory
Access: Mon–Fri 9am–5pm

The central block and wings are all that were built to Ivory's design. The dome is an unfortunate 19th century addition in lieu of Ivory's unfinished spire and capola. Maurice Craig cites the Bluecoat School as one of Dublin's most beautiful and original buildings. The surrounding streets were laid out under Ivory's direction on a grand scale, but the large houses in Blackhall Street have been demolished and replaced with Local Authority housing which does little to enhance the approach to this fine building. In the early 1980s, the Bluecoat School was bought by the Incorporated Law

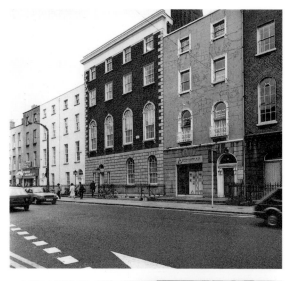

35

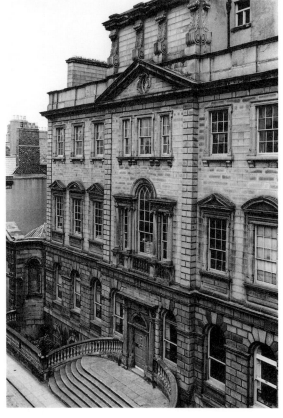

36

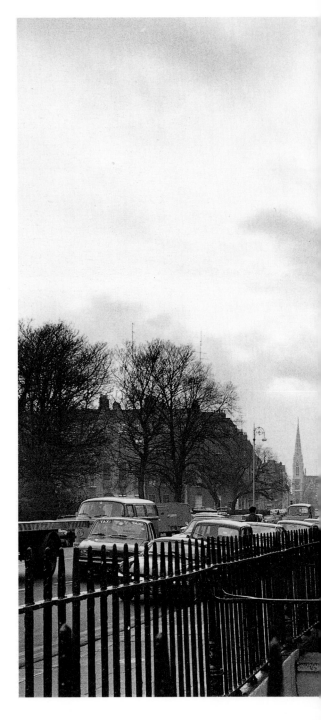

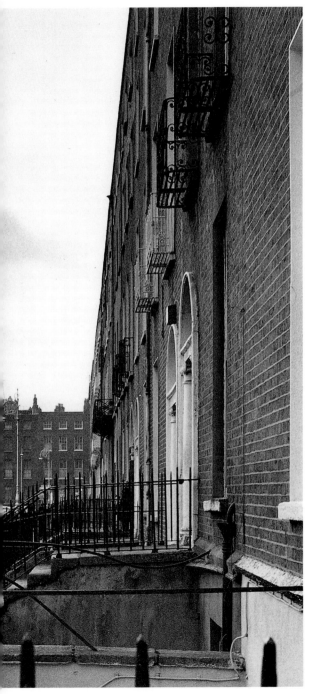

38

Society and was adapted for use as its headquarters by Nolan and Quinlan, architects. Brian O'Connell, architect, is presently (1993) implementing a long-term conservation programme.

38
Mountjoy Square
Dublin 1

Mountjoy Square was a speculative venture by Luke Gardiner 5th Lord Mountjoy and was constructed between 1780 and 1798. The east side is later and was finished c. 1820. It is the only symmetrical Dublin Georgian square (600 x 600ft), with two streets entering each corner. The original intention was to have the houses composed in the grand manner with a central capola and end pavilions. This proposal did not fit with the grain of the city and the square was developed with three-bay terrace houses, eighteen on each side. The square is linked on the axis of Gardiner Street to Gandon's semi-circular Beresford Place around the Custom House. Mountjoy Square is in the poorest condition of any of the Georgian Squares; the south and west sides are sadly decayed and several houses have been demolished.

39
Newcomen's Bank
Castle Street, Dublin 8
1781
Architect: Thomas Ivory
Access: office hours (hall only)

An elegant composition of shallow recessed arches and delicately moulded masonry, Newcomen's Bank is comparable to the work of Robert Adam. The original main façade and entrance was to the south, facing Dublin Castle. The eastern front, facing City Hall, was three bays wide. This front was extended northwards in the mid-19th century and a new entrance porch was provided between the original and new façades. There is a notable internal oval staircase leading to a grand oval office with painted ceilings, which are presently undergoing restoration. The bank is now used as offices by Dublin Corporation.

40
The Four Courts
Inns Quay, Dublin 7
1786
Architect: James Gandon
Access: court hours

The Four Courts and the Custom House (see entry number 42), are Gandon's great riverine buildings. The former contains a pedimented centre linked to end-pavilions by arcaded screens and triumphal arches. The central block is surmounted by a colonnaded rotunda with a shallow neo-classic dome. The five statues on the central block of Moses, Justice and Mercy with Wisdom and Authority, are by Edward Smyth. The complex was bombarded and burnt by Free State Troops when the Civil War broke out in 1922. As a result the interior is much altered. The west range is part of an earlier scheme designed by Thomas Cooley, architect.

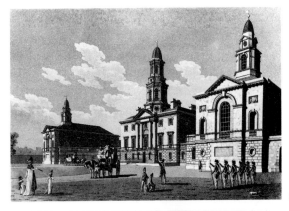

37

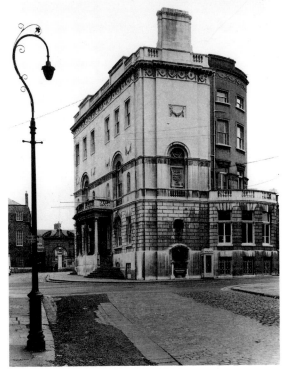

39

41
Belvedere House
Great Denmark Street, Dublin 1
1786
Architect: unknown
Access: on application only

A five-bay mansion with a fluted frieze and cornice, Belvedere House terminates one end of North Great George's Street. The outstanding interior plasterwork is by Michael Stapleton who may also have designed the house. The staircase is lavishly decorated and leads to the Venus, Diana and Apollo Rooms. Since 1841 Belvedere House has been a Jesuit school: James Joyce was a pupil between 1893 and 1898.

42
Custom House
Custom Quay, Dublin 1
1791
Architect: James Gandon
Access: office hours

The Custom House is James Gandon's masterpiece, designed in 1791 with four decorated fronts and superb statuary by Edward Smyth. The south front to the River Liffey has a pedimented central portico surmounted by a domed colonnaded tower and beautifully balanced end-pavilions, with recessed doric columns. The Custom House was gutted by fire in 1921 during the War of Independence. Originally restored by the Office of Public Works in the 1920s, the latest major restoration was completed in 1990 by D. Slattery and A. Lindsay, Office of Public Works. Government offices, including the Department of the Environment, have occupied the building since the 1920s. Gandon's two great riverine buildings continue to dominate the city and it is Dublin's good fortune that Gandon refused an invitation to work in St Petersburg in 1779.

43
The Kings Inns
Henrietta Street, Dublin 1
1785
Architect: James Gandon
Access: Mon–Fri 10am–1pm and 2.30pm–5pm

This is one of James Gandon's last commissions. Designed in 1785, it terminates Henrietta Street with a powerful composition of twin-pedimented wings surmounted by a graceful cupola on paired columns. The west front, which has twin pavilions with caryatid doors, was extended in the 19th century. The statuary and carving is by Edward Smyth. The great Dining Hall is Gandon's only major interior to survive unaltered.

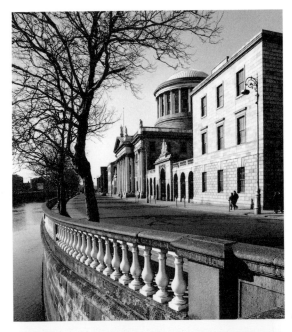

40

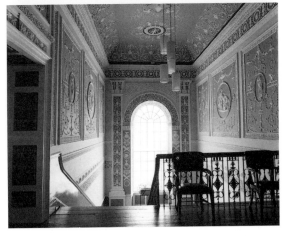

41

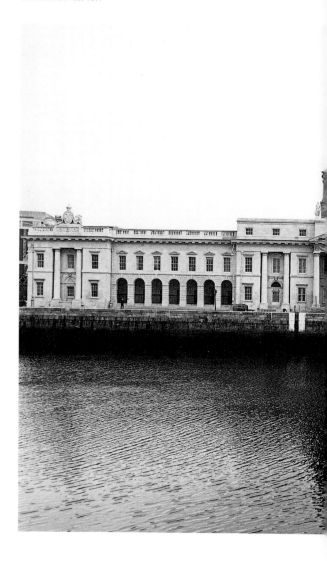

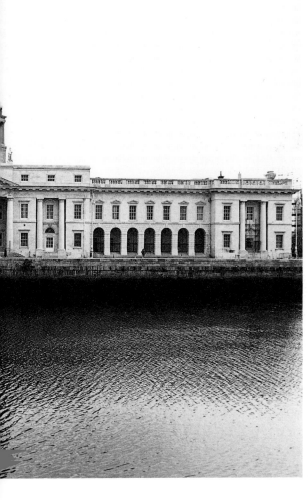

42

44
Royal College of Surgeons
St Stephen's Green, Dublin 2
1806
Architect: Edward Parke
Access: on application only

Parke's three-bay pedimented building was extended by four bays to the north and the pediment recentred by William Murray, architect, in 1825. It was further extended by Buchan Kane and Foley, architects, in 1980. The statuary and Royal Arms in the tympanum are by the sculptor John Smyth, son of Edward.

45
St George's Church
Hardwicke Crescent, Dublin 7
1802
Architect: Francis Johnston
Access: exterior only

St George's is a notable Dublin landmark and is magnificently sited on the focus of three once magnificent, now decayed, Georgian streets. The spire was modelled on St Martin's-in-the-Fields. The interior fittings, carvings and decoration are characteristic of Johnston. It exemplifies the problems caused by declining congregations faced by most Protestant inner-city churches. The spire is in urgent need of restoration and the church was deconsecrated and sold in 1990. The purchasers intended to retain the interior fittings and to use the church as a music/conference centre, but St George's is again for sale.

46
General Post Office
O'Connell Street, Dublin 1
1814
Architect: Francis Johnston
Access: office hours and weekends

The powerful pedimented Ionic portico of the General Post Office spans the pavement of Lower O'Connell Street, and is Johnson's most conspicuous building in Dublin. Much of the building was destroyed in the rising of 1916. It is currently being restored by Dunphy O'Connor Baird, architects.

47
Fitzwilliam Square
Dublin 2

Fitzwilliam Square is the last of the Georgian squares, the smallest, and the best preserved. Laid out in 1791 it was completed c.1820. Fitzwilliam Street Upper, commenced as part of the square, is Dublin's largest intact Georgian streetscape and is almost three-quarters of a mile long, its vista closed by the Dublin mountains. (See also entry number 72.)

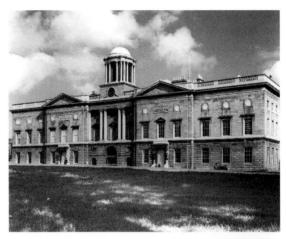

43

44

48
64 Eccles Street
Dublin 1
c.1810
Architect: Francis Johnston
Access: exterior only

Designed by Johnston for his own use the house has an interesting interior including a large octagonal top-lit room at the rear. Johnston died here in 1829 and is buried in the nearby St George's burial ground, Drumcondra. The house is now used as a hostel, and Eccles Street itself is sadly decayed. Johnston also designed the adjoining houses on the Dorset Street side in the same style.

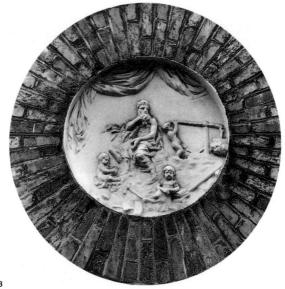

48

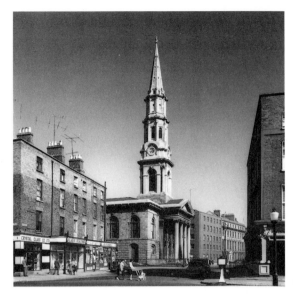

45

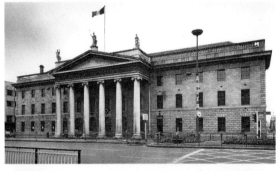

46

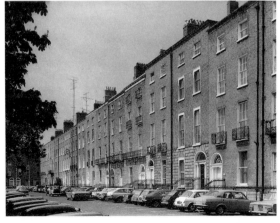

47

The Georgian and Victorian City

Frederick O'Dwyer

The Victorian era saw a decline both in Dublin's fortunes and economic importance. The population in the central area fell. From its peak as the second city in the United Kingdom, it became the tenth. In Ireland it was overtaken in importance by Belfast. Traditional industries such as textiles collapsed although brewing and distilling expanded, Guinness becoming the largest brewery in the kingdom. Jobs were also created with the coming of the railways.

While the union with Britain deprived Dublin of its parliament, the reorganization and expansion of the Irish Civil Service created a significant class of officials. Many chose to live near their offices, ensuring that some areas retained their air of gentility after neighbouring districts had gone into decline. Dublin Castle, seat of the viceroy and focal point of royal visits, hosted an annual season every February and March. The aristocracy, however, who had played a major role in city life in the 18th century, became less visible at social functions. Those who were not complete absentees divided their time between London and their Irish estates. The great Dublin houses of the ascendancy were sold, many ending up as government offices.

The country's first railway line, the Dublin and Kingstown (Dun Laoghaire), opened in 1834 and was later extended to Dalkey, Killiney and Bray, intensifying the exodus of the middle classes to the outskirts. The suburbs were not only fashionable but considered healthier than the city. The introduction of tramways in the 1870s increased the relative attractiveness of inner suburbs like Rathmines, Drumcondra, Glasnevin and Clontarf. There was an expansion of the Roman Catholic middle class, swelled by immigration from the provinces.

Many of Dublin's poor lived in cramped and insanitary accommodation, one third of the population of the inner city subsisting in single-room tenements. The provision of privately built low-cost houses in the 1880s, financed by cheap loans from central government, hastened the decline of large areas of the Georgian city, particularly on the northside, as townhouses were converted into tenements to cater for those displaced by redevelopment.

Dublin's Victorian architecture, while in many ways distinctive, mirrored the fashions, revivals and technical developments elsewhere, the lead, in the main, coming from Britain. The classical tradition flourished longer here (as it did in Scotland) and can be

seen in many of the fine Roman Catholic churches erected after the granting of Catholic Emancipation in 1829. They were often built of black calp with granite or limestone porticos. By the 1840s the Gothic revival was in full swing, popularized by the writings of the English architect A.W.N. Pugin, who called for accurate reinterpretation of medieval structural form and detailing. Pugin's son Edward and his Irish partner G.C. Ashlin designed what is probably Dublin's finest Victorian church, St Augustine & St John's, built of granite with old red sandstone and limestone dressings. Towards the end of the century Romanesque displaced Gothic as the preferred style. Religious orders played a significant role as architectural patrons in 19th century Ireland, and, as in medieval times, built not only churches but convents, schools, colleges and hospitals.

Dublin was well served with Protestant churches, particularly those of the established church. Most new buildings in the city were commissioned by non-conformists, varying in style from neo-classical to spikey Gothic. Perhaps the most important development was the restoration of the two cathedrals. St Patrick's was renovated by Sir Benjamin Lee Guinness in the 1860s at a cost of I£150,000, while the distiller, Henry Roe, restored Christ Church in the 1870s and built the adjoining Synod Hall.

Institutional building was not the sole preserve of the religious orders. A number of Protestant charities and organizations, many dating from Georgian times, were also active, expanding existing premises and commissioning new ones. Public works included the reconstruction of the Dublin workhouses and the extension of the asylum at Grangegorman in the 1840s. An asylum for the criminally insane was erected at Dundrum, while a new prison, Mountjoy, based on the design of Pentonville, was opened in 1850. The government also financed, either directly or through grants, a number of important cultural buildings, including the Natural History Museum, the National Gallery, and the National Library and Museum, Kildare Street.

In the area of popular culture, many fine places of entertainment and public houses were erected. Many of the latter survive with their marble, mahogany and brass interiors intact. Legitimate theatre was performed at the Theatre Royal on Hawkins Street, which first opened in 1821 and at the Queen's, Great Brunswick Street. Music halls were more financially attractive. These included Dan Lowery's Star of Erin (now the Olympia) on Dame Street, and the Tivoli on Burgh Quay.

The London fashion for stuccowork led many Dublin traders, in areas like Dame Street and Sackville (now O'Connell) Street, to 'improve' their façades by plastering over the brickwork, thus destroying the uniformity ordered by the Wide Streets Commissioners in the late 18th century. A few terraces of the London type were built in Dublin, notably at Gloucester Street (demolished), Morehampton Road and Harcourt Terrace. A number of public buildings were altered or extended in the fashionable Greek revival style, including Tyrone House, Marlborough Street.

By the 1850s, there was a huge increase in the variety of building materials available in Dublin. Mechanization and improved

transportation reduced costs to the point where ornate work could be obtained cheaply. Shiny English red brick replaced stucco and the traditional buff brick as a facing material, although it was relatively expensive, rear and side walls often being built of granite rubble (sometimes left unplastered) or cheaper stock brick.

Traditionally calp limestone had been used for rubble walls, since it could be quarried cheaply in the city itself. With the increase in the urban area it had to be obtained from places like Lucan and Finglas, while granite was available relatively closely in the south county, with quarries at Dalkey and in the Dublin mountains. Combinations of different coloured stones or bricks were often used to achieve contrast.

Cut granite, popular as a facing material in Georgian times, was difficult to work for intricate details. Most of the bank and insurance buildings built from the 1860s onwards in areas like Dame Street, College Green and Sackville Street were faced with limestone or sandstone which was easily carved. They are in a variety of styles, from Lombardo Romanesque, associated with early banking, to Scots baronial and baroque. The naturalistic ornament of the celebrated Dublin school of stone-carvers owed its origins to the architectural firm of Deane and Woodward. They were strongly influenced by John Ruskin's ideas on promoting craftsmanship, which they put into practise at the Museum Building, Trinity College and at the former Kildare Street Club.

Towards the end of the century the variety of materials increased with changing fashions. By the 1880s, terracotta, which had a cost advantage over carved stonework, had become popular for moulded details and ornamental panels, usually as dressings to brick façades. Red terracotta was used extensively in the building of the South City Markets, Marlborough (now McKee) Barracks and at the Richmond Hospital. Yellow terracotta was favoured by the Dublin architect Albert E. Murray, who used it in combination with red brick.

The huge advances in technology in the 19th century, particularly the development of cast and wrought iron structural components, meant that entire buildings could be constructed without solid masonry walls. Sheet and plate glass in large sizes became readily available after the dropping of a punitive excise duty in 1845. In practice iron frames were mostly used for internal structures only, solid external walls remaining the norm. At Dublin's main railway stations the iron and glass roofed passenger sheds are hidden behind granite palazzi – Italianate at Connolly and Heuston and neo-Egyptian at Broadstone. The latter, no longer used as a station, is the most successful architecturally, and the masterpiece of J.S. Mulvany, the last great practitioner in the Dublin classical tradition.

While opportunities for using iron and glass structures were limited, Dublin produced two great innovative ironmasters, Robert Mallet, of Ryder's Row and Richard Turner, of the Hammersmith Works, Ballsbridge. The names of both men can be seen on sections of the railing around Trinity College. Mallet was a virtuoso, with an international reputation as a scientist and inventor. Turner provided the roofs for the original Westland Row terminus of the Dublin & Kingstown Railway, and for the Broadstone, as well as

Lime Street Station in Liverpool. His fame largely rests on his conservatories, which include the curvilinear range at Glasnevin and the Palm House at Kew Gardens (1845–48), which was prefabricated in Dublin. London's Crystal Palace (1851), which owed much to Turner's ideas, started a fad for large exhibition buildings. Several were constructed in Dublin during the next sixty years, mostly of a temporary nature. The earliest, more timber and felt than iron and glass, was built on Leinster Lawn in 1853. A more substantial structure, part solid masonry and part glass palace was erected on Earlsfort Terrace in 1865 – the great hall survives as the National Concert Hall. By the turn of the century, reinforced concrete, which was fireproof, had begun to supersede iron framing. The first major structural use of concrete in a Dublin building was at the Royal College of Science, Upper Merrion Street, and in part of the Government Buildings complex designed by the English architect Sir Aston Webb in 1907. It was completed in 1922. Until the late 1950s Dublin still appeared much as it did in Victorian times. It is a matter of regret that many significant buildings of the period disappeared during the ensuing decades when Victorian architecture was unfashionable.

49
Pro Cathedral
Marlborough Street, Dublin 1
1814
Architect: unknown
Access: Mon–Sat 7.30am–8.30pm;
Sun 7.00am–7.00pm

A sublime Greek revival exterior; the interior was modified in execution by the somewhat incongruous insertion of a dome. The plans for the Pro Cathedral were sent from Paris by the exiled United Irishman, John Sweetman, and were probably drawn up by a French architect, possibly L.H. Le Bas. The portico was completed by J.B. Keane in the 1840s.

50
Saint Michael and Saint John's
Exchange Street, Dublin 2
1815
Architect: John Taylor
Access: not possible

An early Gothic revival church with almost identical front and rear elevations and a fine Perpendicular Gothic fan-vaulted ceiling. This was the first Roman Catholic church to be closed due to the declining population in the city centre. Taylor also designed the nearby Protestant church of St Michael of All Angels, demolished by G.E. Street in the 1870s for the synod house of Christ Church Cathedral. Taylor's later career was in Scotland where he designed the Glasgow custom house (1839–40). The future of Saint Michael and Saint John's is uncertain; there is a current proposal to use the church and surrounding buildings as a Viking Museum.

51
Sir Patrick Dunn's Hospital
1816
Architect: Sir Richard Morrison
Access: on application

The plan and massing are derived from the Royal Military Infirmary, which had wards similarly accommodated in pedimented flanking pavilions set forward from the central block. The building also shows Gandon's influence both in massing and detail. Like Gandon, Morrison used plaques, blank arches and niches as façade ornamentations. The entrance hall has a fine coffered ceiling, walls articulated by blank arcades and neo-Greek detailing. Morrison founded the Royal Institute of the Architects of Ireland of which he was the first Vice-President.

52
Halfpenny Bridge
1816
Architect: John Windsor

This elegant iron footbridge (originally Wellington Bridge) was designed by a foreman of the pioneering Coalbrookdale Company, Shropshire, which had fabricated the world's first iron bridge in 1779. It was erected as a private venture by John Claudius

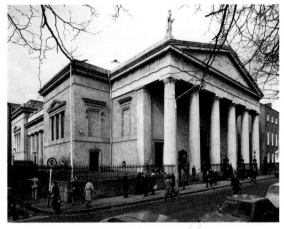

49

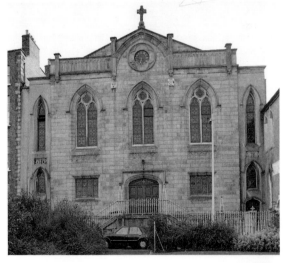

50

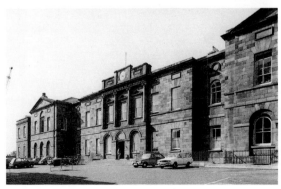

51

52

Beresford and William Walsh at a cost of I£3,000. The bridge acquired its name from the halfpenny tolls which were collected up until 1919. It survived a 1912 proposal for an art gallery (by Lutyens) which the Dublin Corporation rejected after initial encouragement. The Halfpenny Bridge is one of Dublin's most famous landmarks.

53
Wellington Testimonial
Phoenix Park
1817–20
Architect: Robert Smirke
The 205 foot obelisk was built by private subscription following a competition held in 1814. At the time several sites were being considered including Merrion Square and St Stephen's Green. After the erection of the obelisk, the committee ran out of funds so that the intended equestrian statue of Wellington alongside was never put up though a plinth had been built for it, later removed. The fine bronze relief panels at the base, by Hogan, Kirk and Farrell respectively, were erected by the Board of Works in 1861 after the government took over the project.

54
King's Bridge
1823–27
Architect: George Papworth
Named after George IV, who visited Dublin in 1821, this simple span iron bridge was erected in conjunction with the extension of the northern quays and the continuation of Steevens Lane across Royal Hospital lands. The bridge, which has neo-Grec details, was cast by the neighbouring Phoenix Iron Works. Papworth, a member of a distinguished London family of craftsmen and architects, had a long and successful career in Ireland.

55
Saint Stephen's Church
Mount Street Crescent, Dublin 2
1824
Architect: John Bowden
Access: exteriors only and during church services
Built on an island site, its fine Greek revival façade faces down Upper Mount Street and Merrion Square. The shape of the tower, derived from Athenian models, gives the church its nickname 'the pepper canister'. The interior has a Victorian air, due to the later alterations, including the chancel (1852), reordered by Sir Thomas Drew in 1878, and late-19th century furniture and fittings. These include a prayer desk by Cambi of Siena (1891) whose work can also be found in the National Library and Museum and Rathmines Town Hall. (See entries 96 and 103.)

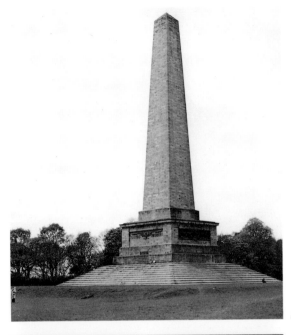

53

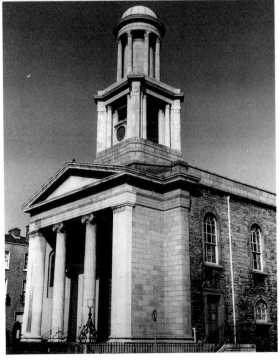

55

56
Saint Mary's Chapel of Ease
Saint Mary's Place, Dublin 1
1830
Architect: John Semple
Access: exteriors only and during church services

A stylized geometric Gothic church, now deconsecrated, with an unusual parabolic vault in solid masonry. This was one of about fifteen churches erected in Leinster by Semple in the years immediately before the abolition of the Board of First Fruits in 1833. Semple's other Dublin churches include Rathmines, which originally also had a stone vault (removed in 1886), Donnybrook and Monkstown. St Mary's is popularly known as the 'Black Church'.

57
Church of Saint Francis Xavier
Upper Gardiner Street, Dublin 1
1832
Architect: John B. Keane
Access: Mon–Sun 7.00am–8.30 pm

The fine façade of this Jesuit church was based on Notre Dame de Lorette, Paris (L.H. Le Bas, 1824). Keane's sumptuous interior was restored in the 1980s. The ceiling design is similar to one that he subsequently used at St Mary's, Clonmel (1836). His other Dublin church, Saint Laurence O'Toole, Seville Place, 1850, was Gothic. Keane got into financial difficulties at about this time and was imprisoned in the city Marshalsea.

58
Saint Andrew's Church
Westland Row, Dublin 1
1832–37
Architect: James Bolger
Access: Mon–Sun 8.00am–8.00pm

This church replaced a building begun by James Leeson and abandoned after the site, elsewhere in the parish, proved unsuitable. Bolger's granite façade, with Doric portico in antis, is flanked by brick parochial houses. Above the pediment is a statue of Saint Andrew. There is a somewhat disappointing columnless interior made even more so by Vatican II inspired alterations. The monument to Jeanette Mary Farrell, a marble relief portrait, is by John Hogan (c. 1843).

59
Department of Education
Marlborough Street/Talbot Street, Dublin 1
1838
Architect: Jacob Owen
Access: office hours (entrance hall only)

The Greek revival remodelling of Tyrone House and the construction of a replica were carried out in 1835–38 by Jacob Owen of the Board of Works, who also did the adjoining block in Talbot Street in 1842. The latter was extended by his son J.H.

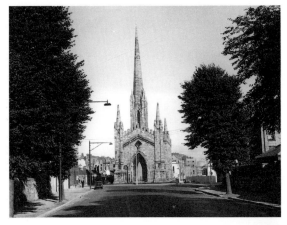

56

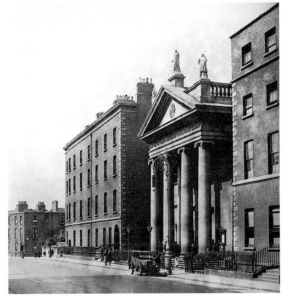

57

Owen in 1859. The original 1830s Model School buildings are by Owen, but the block facing Gardiner Street was designed by Frederick Darley (1858–61).

60
Saint Paul's
Arran Quay, Dublin 1
1837
Architect: Patrick Byrne
Access: Mon–Sun 8.00am–6.00pm

This building replaced an old chapel in the parish and was the first of a series of Dublin churches designed by Byrne in the years immediately after Catholic Emancipation. The tetrastyle portico is surmounted by statues (Saint Paul by C. Panormo, Saints Patrick and Peter by J.R. Kirk), and a tower with a copper dome echoing the nearby Four Courts. The chancel is located behind a columnar screen, designed as an Ionic portico in antis. In the top-lit apse is a painted altarpiece, after Rubens, depicting the conversion of Saint Paul.

61
Saint Audeon's Church
High Street, Dublin 8
1841–46
Architect: Patrick Byrne
Access: Mon–Sun 8.00am–6.00pm

This fine classical church stands on a dramatic site, with calp rubble walls rising from the hillside, broken only by windows at a very high level. Internally the plasterwork is of high quality, the windows lighting through a barrel of vaulted ceiling. The walls are decorated with a giant order of Corinthian pilasters with inset niches. There was originally a dome over the crossing, but it collapsed in 1884. The portico, by G.C. Ashlin, was not built until 1893.

62
Connolly Station
Aimes Street, Dublin 1
1844
Architect: William Deane Butler
Access: Mon–Sun 7.30am–10.15pm

The first of four main Dublin termini to be built and easily outclassed by the others, though no less attractive for that, with its Italiante towers (see also entries 63, 65 and 79). This feature is echoed in the tower of the former Great Northern Railway office, a red brick building with Dumfries sandstone dressings, erected on the northern side of the station in 1879, architect John Lanyon of Belfast. Further up the street is the former parcel post depot, also red brick, by J. Howard Pentland of the Office of Public Works (1892).

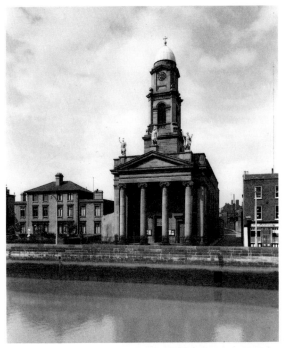

60

61

63
Heuston Station
Kingsbridge, Dublin 8
1845
Architect: Sancton Wood
Access: Mon–Sun 7.30am–10.30pm

Built following an architectural competition and awarded to the London-based Wood (instead of the local Mulvany) at the behest of the British directors of the railway company. Wood later designed some of the neo-Gothic stations on the line. The main block is an Italianate palazzo, while the low façade to John's Road is more severely neo-classical. The roof of the passenger shed, with its lightweight iron trusses, was designed by the Irish engineer Sir John McNeill and constructed by the Dublin firm of J. & R. Mallet. A similar roof on Mallet's own works at Phibsboro was taken down in 1991.

64
Mount Jerome Cemetery
Harold's Cross Road, Dublin 6
(Bus Nos 16/16A/49/49A/65)
Access: Mon–Sat 9.00am–4.00pm;
Sun 1.00pm–4.00pm

The cemetery at Mount Jerome is Ireland's 'Père-Lachaise'. It contains a remarkable array of Victorian monuments to Dublin's merchant and professional classes. It is the burial place of several noted architects including J.S. Mulvany, Jacob Owen and the Morrissons. The gate lodge was designed by George Papworth in 1835. The chapel is by William Atkins of Cork and was built in 1845. The cemetery also contains the Drummond memorial by Papworth (1840) and the Cusack monument by Sandham Symes (1861). Also buried here are Thomas Davis, Sir William Wilde and George William Russell (A.E.).

65
Broadstone Station
Phibsboro, Dublin 7
1846–50
Architect: John Skipton Mulvany
Access: Mon–Sun 7.30am–12.00pm

This is the neo-Egyptian masterpiece of the last of the great Dublin classicists, with skilful modelling in mountain granite. The passenger shed roof is by the celebrated ironmaster Richard Turner. The colonnaded cab shelter on the east side of the building is by George Wilkinson (1861). Closed to rail traffic in 1937, the station is now used as a bus depot.

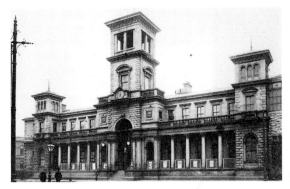

62

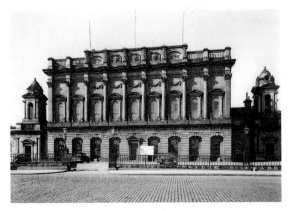

63

65

66
Church of Our Lady of Refuge
Rathmines Road, Dublin 6
1850
Architect: Patrick Byrne
Access: Mon–Sun 8.00am–9.00pm

This fine cruciform church is said to have been built with the contributions of servants in this expanding suburb of Rathmines. It was destroyed by fire in the 1920s and restored by Ralph Byrne who added a magnificent copper dome which is now a notable Dublin landmark.

67
Royal Irish Academy
Dawson Street, Dublin 2
1852–54
Architect: F.V. Clarendon, Office of Public Works
Access: Mon–Fri 10.00am–5.00pm

The top-lit library and meeting room were built on the site of old billiards rooms at the rear of Northland House, an 18th century mansion acquired by the Academy in 1852. The work was financed by a parliamentary grant and entrusted to the Office of Public Works, who appointed Clarendon (officially a clerk of works) as architect. The design is most accomplished. The plasterwork conceals the elaborate iron framing devised and fabricated by Robert Mallet (see also entry number 63) to support the galleries and roofs of each room. The design of the meeting room seems to have been based on Hardwick's booking hall at Euston Station.

68
Campanile
Trinity College, Dublin 2
1852–56
Architect: Sir Charles Lanyon

A nicely proportioned Italianate bell tower by a successful Belfast-based architect and local politician. A range of buildings had formerly stood on its site, with an earlier campanile by Richard Cassels. From the 1830s there were proposals for new buildings, but these were dropped after the campanile was suggested by the architect Decimus Burton in 1849.

69
Museum Building
Trinity College, Dublin 2
1853–57
Architects: Deane and Woodward (with John McCurdy)
Access: exterior only

The Museum Building was a successful competition design by a Cork firm of architects who later won the Oxford Museum competition. Woodward was much influenced by *The Stones of Venice*. Ruskin's influence may be seen in the naturalistic carving, by the O'Shea brothers, and the use of polychromy, notably in the fine central stair hall with its twin domes. Several stone capitals were designed by the Pre-Raphaelite painter J.E. Millais (for

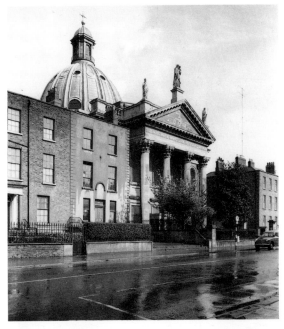

66

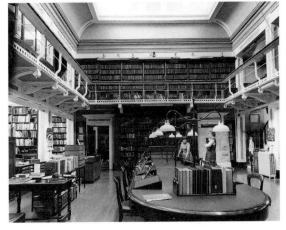

67

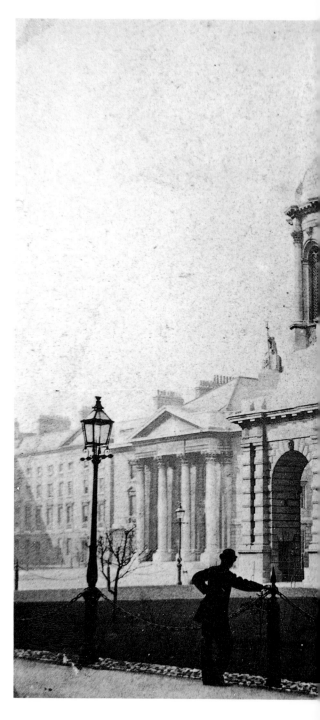

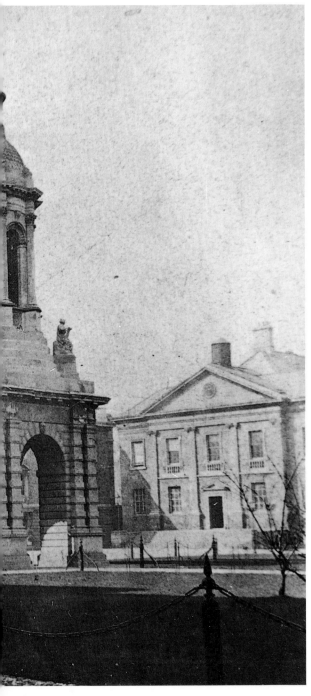

example the mice eating corn over the entrance). Note the contrast with the elevations to earlier ranges in New Square by Frederick Darley (1838–44).

70
Graduates' Memorial Building
Trinity College, Dublin 2
1891–1902
Architect: Sir Thomas Drew
Access: exterior only
Built on the site of Rotten Row, a range of early 18th century buildings on the north side of Library Square, the Graduates' Memorial Building was conceived in the college's tercentenary year to house the various college societies. Progress was slow however, and it was not until 1899 that the plans of Thomas Drew (selected in competition with T.N. Deane and Robert Stirling), were approved. Drew's Jacobethan design has a lively skyline contrasting with its classical neighbours. The building, which is partly residential, was not completed until 1902.

71
National Irish Bank
O'Connell Street, Dublin 1
1853
Architect: David Bryce
Access: banking hours
A former Standard Life office by the noted Edinburgh architect, with a good hexastyle Corinthian portico, rising from first floor across the entire façade, which is built of red sandstone. The carved figures in the tympanum representing the wise and foolish virgins, are by Scots sculptor Sir John Steel and are based on his earlier work for Bryce at the company's Edinburgh office. Byrce built two other insurance/assurance buildings in Dublin, one of which, 28 College Green (1868), was demolished in 1974. The other is on Dame Street (see entry number 90).

72
28 Fitzwilliam Place
Dublin 2
1854–55
Architects: Deane & Woodward
Access: on application only
Number 28 is a corner house at the junction of Fitzwilliam Place with Leeson Street. It was designed for a lawyer relative of Woodward, Hans Henry Hamilton, whose initials may be seen picked out in the brickwork. The building is a Gothic reinterpretation of the Dublin Georgian house type. A chapel was added later to the rear by G.C. Ashlin. The adjoining terrace, though Georgian in appearance, is actually contemporary.

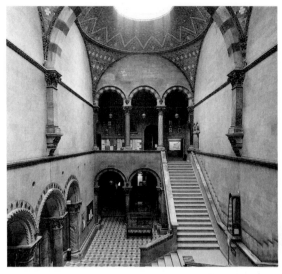

69

70

73
University Church
St Stephen's Green, Dublin 2
1855–56
Architect: John Hungerford Pollen
Access: Mon–Sat 9.00am–6.00pm;
church services Sunday

A Byzantine basilica, University Church was designed by an
English artist who was appointed by Cardinal Newman to the
professorship of fine art at the short-lived Catholic University. The
original painted wall panels are in urgent need of restoration. The
porch was added by Pollen in 1860. While in Dublin, he befriended
Woodward and decorated several of his buildings.

74
Mater Misericordia Hospital
Eccles Street, Dublin 1
1855–61
Architect: John Bourke
Access: hospital visiting hours

Built on the site of the projected Royal Circus (1796), the Mater
has what is arguably Dublin's last great classical façade, with a fine
recessed portico in Ballyknockan granite. After his appointment by
the Sisters of Mercy in 1851, Bourke made a study of British and
continental hospitals. The U-shaped plan was built in sections, the
main front being completed in 1861, the east and west wings
being commenced in 1868 and 1884 respectively.

75
Natural History Museum
Merrion Square, Dublin 2
1856–57
Architect: Frederick Villiers Clarendon
Access: Tues–Sat 10.00am–6.00pm; Sun 2.00pm–5.00pm

A granite palazzo on Leinster Lawn with elevations detailed to
harmonize with Leinster House. The museum was built for the
Royal Dublin Society at a cost of I£11,000, partly funded by a
parliamentary grant. As at the Royal Irish Academy (see entry
number 67) there are top-lit galleries. The trebated internal
structure may well reflect Clarendon's early work as an engineer.
The main elevation, with windows only on the ground floor,
probably derives some of its vocabulary from the former
Parliament House and College Green with hints at European
sources.

76
National Gallery of Ireland
Merrion Square, Dublin 2
1856–64
Architects: various
Access: Mon–Sat 10.00am–6.00pm; Sun 2.00pm–5.00pm

The elevations were designed to match the earlier Museum of
Natural History. The Gallery was the subject of a protracted design
process, the initial scheme having been provided by an amateur

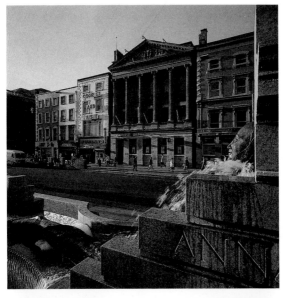

71

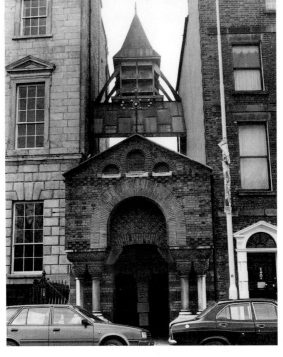

73

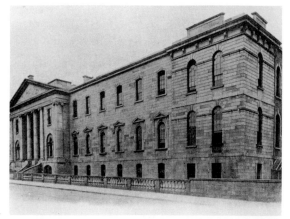

74

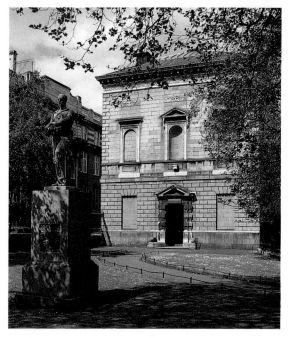

75

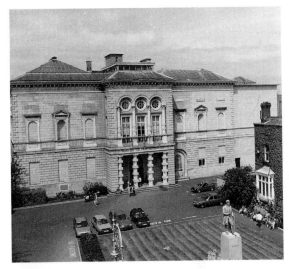

76

77

78

architect. Charles Lanyon was involved for a time, but it was Captain Francis Fowke who brought the building to completion. It was extended in 1903 by Sir Thomas Manly Deane and again in 1969 by Frank Duberry of the Office of Public Works. The entrance area was remodelled in 1991 by the Office of Public Works.

77

Saint Stephen's Schools

Northumberland Road, Dublin 4
1856–61
Architects: Deane & Woodward
Access: on application only

Saint Stephen's Schools is one of three Dublin schools by this practice. Saint Ann's Schools Molesworth Street were demolished in 1978. The other survivor, in Dundrum, was converted to offices in 1990. Woodward's penchant for geometry is evident in the façade proportions determined by the equilateral triangles of the gables. The striking chimneys and conical stair tower add verticality to a horizontal building.

78

Kildare Street Club

1 Kildare Street, Dublin 2
1858–61
Architects: Deane & Woodward
Access: exteriors only

The Kildare Club is remarkable for its stone carving, which includes billiard playing monkeys, a witty interpretation of Ruskin's advocation of naturalistic ornament. C.W. Harrison is responsible for much of the sculpture, some of which may be by the famed O'Shea brothers. The club was among the first of many buildings in Dublin to be faced with red Bridgewater brick (instead of the traditional stock brick). The interior was divided into two and modernized in recent years. The interiors in the left hand half of the building, including a magnificent staircase, were destroyed in 1971, but original features may be seen in the half converted to house the state Heraldic Museum and Library.

79

Harcourt Street Station

Dublin 2
1859
Architect: George Wilkinson
Access: exteriors only

A fine Roman baroque design by the architect of Ireland's workhouses. The railway line was closed on its centenary. The entrance was in the granite-colonnaded front, with a central archway, facing Harcourt Street, which led to the platforms at an upper level, in the massive calp-faced passenger shed. This was raised over a vaulted basement, housing bonded stores, recently restored to use by a wine merchant.

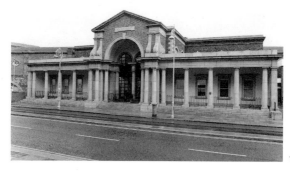

79

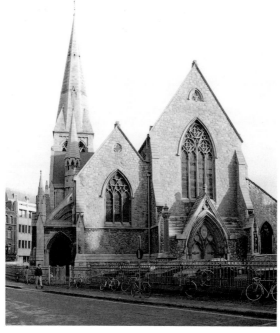

80

80
Saint Andrew's Church
Suffolk Street, Dublin 2
1860
Architects: Lanyon Lynn & Lanyon
Access: exteriors and during church services

This competition-winning design was built on the restricted site of an earlier church destroyed by fire. The old building, known as the Round Church, dated from the 17th century, with a tower by Francis Johnston *c*.1800. William H. Lynn's premiated design was more elaborately detailed than the executed building, which relies for effect on massing and the contrast between polygonal rubble walling and dressed stone. The granite spire terminates the vista down Nassau Street.

81
Unitarian Church
St Stephen's Green, Dublin 2
1860
Architects: Lanyon Lynn & Lanyon
Access: exteriors and during church services

An attractive infill design formerly in Georgian streetscape but now surrounded by office buildings. The church proper is at first-floor level, reached by an internal staircase. The compact plan incorporates a church hall at ground-floor level. The architect William H.Lynn even managed to squeeze a slender bell tower and spire into the angle of the nave.

82
Augustinian Church
John's Lane, Dublin 8
1860
Architects: E.W. Pugin and G.C. Ashlin
Access: exteriors and during church services

A French Gothic masterpiece in granite, limestone and sandstone, effectively sited on falling ground, with tower and spire dramatizing the Liffey skyline. While the initial design was prepared (apparently by Pugin) in 1860, building did not begin until two years later and continued for over three decades. The 160 foot stone spire was not completed until 1884. The chancel was completed by William Hague in 1895.

83
Masonic Hall
Molesworth Street, Dublin 2
1860
Architect: Edward Holmes
Access: Mon–Fri 11.00am–4.00pm
(June, July and August only)

A competition-winning design by the Birmingham architect Edward Holmes, who had earlier designed the Birmingham Lodge. He defeated a number of Dublin architects, including T.N. Deane whose classical design was runner-up. Three orders of classical architecture are used on the façade, Doric on the ground-floor

81

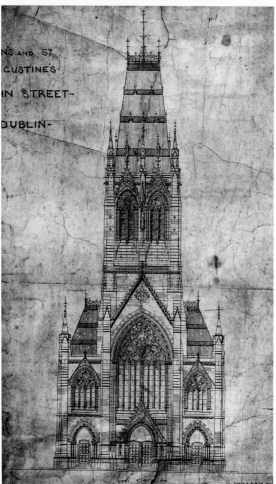

82

portico, Ionic on the first floor and Corinthian above, supporting the entablature and pediment. The interiors are remarkable and include the Grand Lodge Room, with murals by Edward Gibson, the Royal Arch Room and the Prince Masons' Room.

84

Royal College of Physicians of Ireland

Kildare Street, Dublin 2
1861
Architect: W.G. Murray
Access: exteriors, on application only

Built on the site of the original Kildare Street Club, Murray's design defeated five other architects in competition. The conditions stipulated that no Gothic design would be accepted. Internally there is a fine sequence of lofty spaces, with a grand staircase leading to the two main halls at first-floor level. The second of these rooms, the convocation hall, was added in 1874 from the designs of John McCurdy. The stonework of the classical façade unfortunately decayed and was replaced in facsimile by Desmond Fitzgerald in the 1950s.

85

Saint Saviour's Church

Lower Domnick Street, Dublin 1
1861
Architect: J.J. McCarthy
Access: exteriors and during church services

This decorated Gothic church, located in a now sadly depleted Georgian streetscape, was designed by the most prolific of Irish Gothic revivalist architects. A projected tower was never built. The fine marble high altar and reredos were sadly destroyed in the name of liturgical reform. The adjacent priory is by J.L. Robinson (1885) with later additions.

86

Abbey Presbyterian (Findlater's) Church

Parnell Square, Dublin 2
1861–62
Architect: Andrew Heiton
Access: 10.00am–2.00pm
(July, August and September only)

Known as Findlater's Church, this is one of three Dublin churches by the Scottish architect. All three churches were designed in neo-Gothic rather than the traditional classical style favoured by Irish non-conformists before this date. Heiton's plans for his slightly earlier church at Rathgar were adapted by George Cockburn for York Road, Dun Laoghaire.

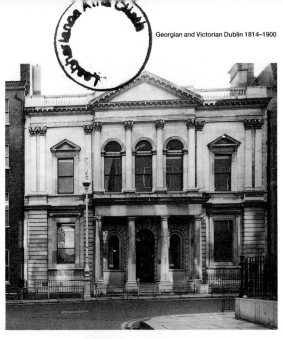

84

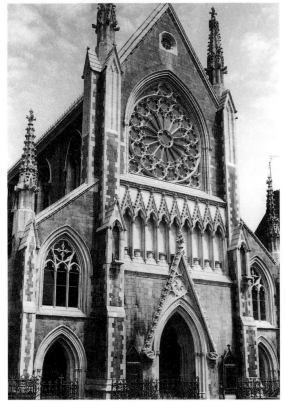

85

87
Merrion Hall
Lower Merrion Street, Dublin 2
1862
Architect: Alfred Gresham Jones
Access: exteriors only

Only the eclectic classical façade (now facing a hotel) survives of this non-conformist church by perhaps the most mannerist of Dublin's Victorian architects. The theatre-like galleried interior survived the closure of the church but was gutted by fire in 1991 and demolished in 1992. The front façade was retained as part of a new hotel by J. O'Connor of A. Gibney and Partners.

88
College Green
Dublin 2

College Green contains Victorian banking and commercial palazzi in a variety of revival styles including Northern (formerly Hibernian) Bank by W.G. Murray (1862–67), extended by Sir Thomas Drew (1873) and Ralph Byrne (1925), and the Ulster Bank also by Drew (1891), the interior demolished (1976). Fox's cigar shop by T.N. Deane and Son (1881), is a pivotal building on the corner of Grafton Street, beyond which is the Trustee Savings Bank (formerly Northern Bank) by W.H. Lynn (1903). The Bank of Ireland (old National Bank) and Allied Irish Bank (Foster Place) are the products of several periods of development; the former is by Barnes and Farrell (1842) with much subsequent remodelling, while the latter is Georgian, with later alterations by George Papworth. The banking halls of both were designed by Charles Geoghegan (in 1889 and 1859 respectively). Number 9 College Green is by Horace Porter (1909).

89
Shelbourne Hotel
St Stephen's Green, Dublin 2
1867
Architect: John McCurdy
Access: hotel hours

The symmetrical front elevation with bay windows is modelled on London's Langham Hotel. McCurdy was arguably the most successful commercial architect of his day, though his work is often rather dull. His first large hotel was the Royal Marine in Dun Laoghaire (1863). The Shelbourne is probably his best Dublin building, with nicely contrasting red-brickwork and cream-painted stucco. There is also a wealth of frothy plasterwork in the interior which was restored in the 1980s.

90
Dame Street
Dublin 2

Dame Street is the continuation of College Green. On the north side corner of Fownes Street is the former Crown Life building in Lombardo Romanesque style by T.N. Deane (1868). He also designed the Allied Irish Bank (old Munster and Leinster Bank) at

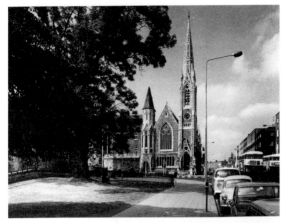

86

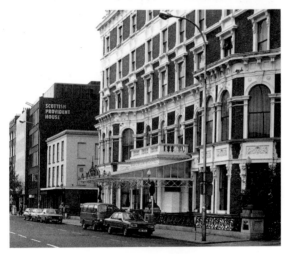

89

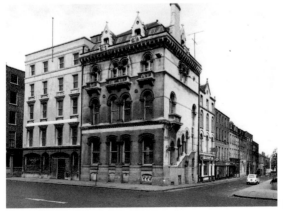

90

the corner of Palace Street (1872) which was extended by
McDonnell and Dixon in 1958 and recently cleaned. The older
Allied Irish Bank branch (formerly the Royal Bank), in red
sandstone, is by W.H. Lynn (1893) while the nearby Trinity Bank is
by David Bryce of Edinburgh (1864). On the opposite corner of
Trinity Street is the former Star Insurance building, in a hybrid style
by A. Blomfield Jackson (1905). Further west no. 31, the former
Caledonian Insurance building is by Woodward's pupil James E.
Rogers (1865), while nos 13–16 (formerly Callaghan's) are by J.J.
O'Callaghan (1879). His Dolphin Hotel in nearby Essex Street
(1898) survives as a façade to a modern office block. O'Callaghan
also worked on what is now the Olympia Theatre (1879–81) which
was subsequently remodelled by R.N. Bruton in 1897.

91
Church of Saint Mary of the Angels
Church Street, Dublin 7
1868–81
Architect: J.J. McCarthy
Access: Mon–Sun 8.00am–9.00pm
This Capuchin church with massive calp limestone walls with
windows set in recessed panels and a high slated roof, impresses
by its scale and articulation rather than by any elaboration of detail.
The interior is dominated by the fine timber-sheeted vault over the
nave, braced by iron ties. The church was built over a lengthy
period, during which the plan was enlarged, perhaps at the
expense of the projected, but unexecuted, tower and spire.

92
Westmoreland Street
Dublin 2
Many Victorian buildings were inserted into the regular façades of
the Wide Streets Commissioners' streetscape. The most notable is
Air Canada (originally a music shop), a fine Ruskinian exercise by
W.G. Murray (1867–70) which contrasts with his nearby former
Provincial Bank on College Street and Fleet Street (1867). Coal
Distributors Limited by G.C. Ashlin (1886–87), a former Scottish
Widows building at the corner of College Street by T.N. Deane
(1875), Beshoff's, also by Murray (1866), and the remarkable Irish
Civil Service office at the apex with D'Olier Street by J.J.
O'Callaghan (1895), were all originally built for insurance
companies. The last named building was known by
contemporaries as 'O'Callaghan's chance' because of its
prominent location.

93
Gaiety Theatre
South King Street, Dublin 2
1871
Architect: C.J. Phipps
Access: theatre hours
C.J. Phipps was the major English theatre architect of the day. The
Gaiety has a fine Victorian auditorium in gilt and stucco and a more
restrained exterior in yellow brick with red brick bands. The

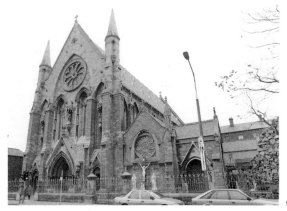

91

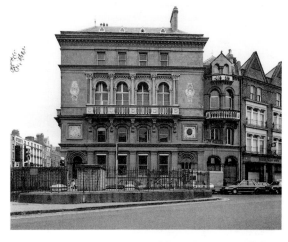

92

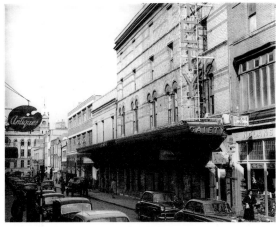

93

proprietor Michael Gunn subsequently purchased the Theatre Royal in Hawkins Street. When that building was destroyed by fire in 1880, Gunn replaced it with a music hall, also by Phipps, transferring the royal patent for legitimate theatre to the Gaiety. The Hawkins Street building was demolished in the 1930s.

94

South City Markets

South Great Georges Street, Dublin 2
1878–81
Architects: Lockwood and Mawson
Access: market trading hours

This is a fine Gothic red brick and terracotta confection by a Bradford firm of architects. The glass-roofed market interior was destroyed by fire in 1892 and rebuilt with intersecting arcades by W.H. Byrne, architect. The surviving towers were also taken down. Byrne was responsible for much of the comprehensive redevelopment of the surrounding streets for the market company, though the Central Hotel was designed by Millar & Symes (1887).

95

Former Jervis Street Hospital

Jervis Street, Dublin 1
1884–87
Architect: Charles Geoghegan
Access: exteriors only

This building replaced an earlier hospital on the site known as the Charitable Infirmary. Geoghegan's design incorporated a number of innovations, with concrete floors, and a flat roof intended as an exercise ground for patients. It was apparently the tallest building in Dublin for many years, even though it was only four stories over basement. The wards had high ceilings for ventilation and a fireplace between each pair of beds. In contrast to the stone and brick façade, the corridors at the rear were constructed of iron and glass to double as an airing space for convalescents. The hospital closed in 1985.

96

National Library and Museum

Kildare Street, Dublin 2
1885–90
Architects: T.N. Deane & Son
Access: Mon 10.00am–9.00 pm;
Tues/Weds 2.00 pm–9.00pm; Thurs/Fri 10.00am–5.00pm;
Sat 10.00 am–1.00pm

A competition-winning design in the classical idiom, the building was designed by a practice noted for Gothicism. It is notable for the well-proportioned neo-Palladian elevations to Kildare Street. The sandstone dressings have decayed badly necessitating the refacing of much of the Library. The best interiors are the Library reading room and the Schinkel-inspired Museum entrance hall. The fine carved doors and panelling are by Carlo Cambi of Siena.

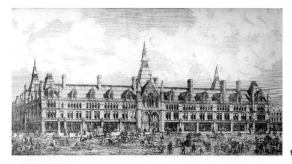

94

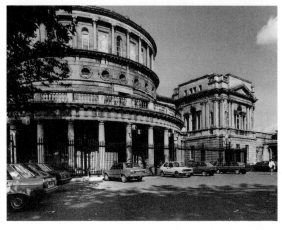

96

97
McKee (formerly Marlborough) Barracks
Blackhorse Avenue, Dublin 7
1888–93
Architects: Captain J.T. Marsh RE and Major R.M. Barklie RE
Access: on application only
McKee was one of the last great barracks to be built in Dublin.
Designed in red brick Gothic style, it is similar to the South City
Markets, tempered with Queen Anne detailing. The barracks are
popularly, though erroneously, believed to have been designed for
a site in India.

98
Corporation Fruit and Vegetable Markets
Mary's Lane, Dublin 1
1889–92
Architect: Spencer Harty
Access: market trading hours
Harty was the engineer to Dublin Corporation and this covered
market, one of two in the area, is his best known building. The
slated roof is supported on iron columns. The main façades are
vigorously detailed, with variegated brick panels, interspersed with
wrought iron screens and topped by terracotta work. The
monumental columnar entrances are built in limestone.

99
Bruxelles
Harry Street, Dublin 2
c.1890
Architect: J.J. O'Callaghan
Access: pub hours
O'Callaghan, an early associate of Deane and Woodward, kept the
Gothic revival banner flying right up to the end of the century. This
building, built for the Mooney chain, is perhaps the finest of his
many Dublin pubs in that idiom. The 1890s, a period of economic
recession, was the golden age of Dublin pub architecture.
Elements of the façade are skillfully carried through in the design of
the adjoining building, presumably also by O'Callaghan.

100
Royal City of Dublin Hospital
Baggot Street, Dublin 2
1892
Architect: Albert E. Murray
Access: hospital hours
The hospital is the brick and terracotta centre-piece of a Victorian
streetscape which includes a number of late Gothic buildings by
J.J. O'Callaghan. Murray, last member of a noted architectural
dynasty, was fond of contrasting these materials – dubbed
Murray's Mellow Mixture (after a tobacco of the day). Other
examples can be seen in Dawson Street, Lord Edward Street and
Parnell Square.

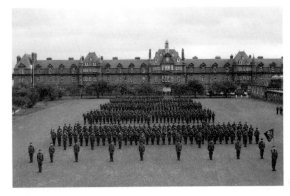

97

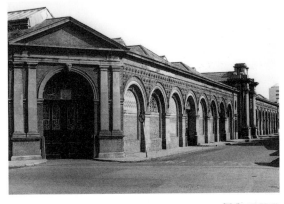

98

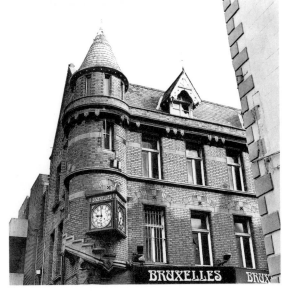

99

101
Arnott's
Henry Street, Dublin 1
1894
Architect: George P. Beater
Access: shopping hours

Beater's design was highly ornate with a brick and terracotta
façade and a central tower topped by an elaborate copper-clad
dome. In 1949 the superstructure of the tower and two subsidiary
domes on the roof were taken down on the grounds that they were
'pieces of misconceived Victorian decoration'. The airy top-lit
interior probably derives from American stores of the period. The
illustration shows the building with the tower and subsidiary
domes.

102
The Stag's Head
Dame Court, Dublin 2
1895
Architect: A.J. McGloughlin
Access: pub hours

One of Dublin's classic pubs with fine panelling, brasswork and
stained glass. A fine perspectivist, McGloughlin was employed for
many years by G.C. Ashlin, for whom he acted as site architect on
the construction of Portrane Asylum (begun 1896), before moving
to New York, where he ended his career designing skyscrapers.

103
Rathmines Town Hall
Rathmines Road, Dublin 8
1897–99
Architect: Sir Thomas Drew
Access: office hours

Inspired by the new town halls in Britain, Drew's Victorian baroque
free-style palazzo was a symbol of the independence and
prosperity of the Rathmines Town Commissioners. The old red
sandstone façade with its copper-domed tower closes the vista up
Rathmines Road, and is an architectural counterpoint to the dome
of the Catholic church at the city end. The chimneypiece in the
former council chamber is by Carlo Cambi of Siena (see entry
number 96).

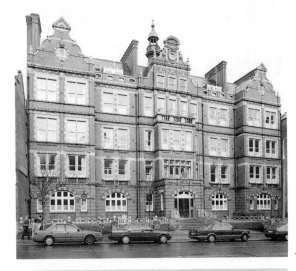

100

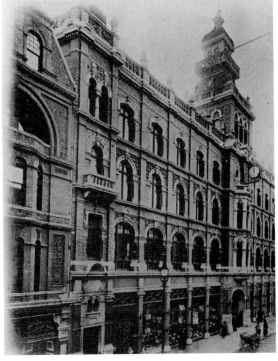

101

The Modern City
Sean Rothery

At the beginning of the 20th century Ireland was already experiencing the influence of the avant-garde movements in design both from Europe and America. In addition, swift advances in building technology began to change the face of architecture. Steel framing, as developed in the United States, began to replace old-established building methods; the great Market Street Store House in the Guinness brewery was a significantly advanced multi-storey steel-framed structure. The growing use of reinforced concrete ensured that, at least in terms of structure, most new buildings began to change radically.

In the early part of the century, however, two powerful influences of the previous century remained. On the one hand the strong classical tradition was still alive; the memory of Gandon in the Dublin Custom House influenced Sir Aston Webb's College of Science in Merrion Street, now recycled as government offices. The other important architectural movement was the arts and crafts tradition of the late-19th century and this flourished into the early years of the 20th century. Its influence can be seen in the Iveagh Buildings and Baths and is notable in many houses in the older suburbs. The best building in this tradition was produced by Edwin Lutyens on Lambay Island but the same architect returned to the classical tradition for his beautiful Irish National War memorial of Islandbridge.

The coming of Independence in 1922 ushered in large programmes of hospital, school and municipal housing. In the 1930s the Dublin Corporation Housing Architects' Department, under the enlightened leadership of A.G. Simms, produced a large and innovative series of municipal flats schemes which were heavily influenced by the imaginative work of the Dutch architects of the Amsterdam School. The International Style of modern architecture came to Ireland in the 1930s with the design of the new Airport Terminal for Dublin. When this was completed in 1940 it was one of the most advanced modern buildings of Europe.

The Dublin Bus Station (now Busarus), of 1944–52, was one of the first post-war European examples of the International Style and was widely influential in spreading this style in the later years. In the early 1960s buildings such as the new Library in Trinity College continued the advance of modern architecture and the traditional and classical revivals largely died. Again starting in the late 1950s and greatly increasing in volume throughout the 1960s, large-scale building of commercial offices dominated the Dublin

scene. Many of these are now showing their age and the obvious influence of narrow cost considerations over the age-old tradition of building for long life.

The rise of the conservation movement in the early 1970s, which grew out of public disquiet at the disappearance of familiar landmarks and particularly a rediscovery of the lovely heritage of Dublin's Georgian buildings, influenced the development of an architecture which respected its context and the historic past. A notable development of the 1980s has been the widespread recycling of redundant traditional buildings. Some of the most successful examples of this include the Powerscourt Town House which was converted to a shopping centre; the old Railway Goods terminus on the Quays which was converted into an entertainment complex, now called the Point and the Guinness Hop Store, now an art gallery. The most recent architecture of Dublin shows concern for texture and materials and often uses traditional stone or brick as facings. Traditional skylines are also more likely to be reflected in the variegated roof lines of the buildings of the 1990s. The architecture of the twentieth century in Dublin is a rich tapestry of styles and faithfully reflects the influence of the modern international design movements which give the century its own special character.

104
Sunlight Chambers
Parliament Street, Dublin 2
1901
Architect: Edward Ould
Access: exterior only

An early office building, designed by a Liverpool architect, who also worked for Lever Brothers at Post Sunlight. It incorporates Italianate features and is somewhat influenced by Norman Shaw. The building is in an attractive Lombardo-Romanesque style and is notable for the two bands of glazed reliefs illustrating the history of soap and hygiene which run around the façade, and the red tile roof.

105
Government Buildings
Merrion Street, Dublin 2
1922
Architects: Austin Webb and T.M. Deane
Access: Sat only; 10.30am–3.00pm (winter)
and 10.30am–4.45pm (summer)

The building is in the Edwardian baroque style, and consists of two blocks linked by a monumental column screen. The construction of the offices was protracted. Work stopped at one stage because it was rumoured that the British were awaiting the outcome of the Home Rule Bill. Although the building had an Edwardian baroque exterior its interior was particularly up-to-date with concrete floors, electric power and lifts. At the time of its completion, in March 1922, British Rule had ended. The North Block, assigned to the Department of Local Government, also housed the Executive Council of the New State. Because of the burning of the Customs House and other buildings, office space was at a premium. The building was converted in 1989 and restored as offices for An Taoiseach by K. Unger, D.L. Byers and A. Rofle of the Office of Public Works. The newly cleaned stonework and floodlighting provide an appropriate and dignified setting for the offices of the Irish Government.

106
Dublin Municipal Technical School
Bolton Street, Dublin 1
1912
Architect: C.J. McCarthy
Access: office hours

A restrained Queen Anne building with a façade in red brick and Mount Charles sandstone plinth and dressings, it is notable as the first building in Ireland specifically built for vocational education. It was extended in 1961 by Hooper & Mayne, architects (with Donal O'Dwyer). A further extension by D. McMahon of Gilroy McMahon, architects, in 1987, carefully organized various functional requirements around a dynamic multilevel social space and a landscaped courtyard. The College of Technology, in addition to other facilities, houses one of the two schools of architecture in Ireland.

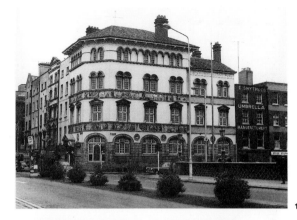

104

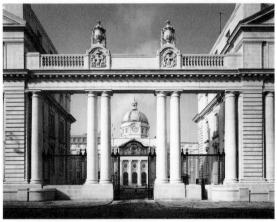

105

106

107
University College Dublin
Earlsfort Terrace, Dublin 2
Architects: Doolin and Butler
Access: concert times only
This was the winning design in an architectural competition held in
1912. It is a severe neo-classical building in light grey limestone
with an attic storey over a strong cornice which emphasizes the
horizontality of the design. It was one of the last public buildings in
Dublin to be constructed with solid stone external walls. In 1981 it
was converted to the National Concert Hall by M. O'Dohery and A.
Smith of the Office of Public Works.

108
Garda Station
Pearse Street, Dublin 2
1915
Architects: A. Robinson, M.J. Burke, H.G. Leask,
Office of Public Works
Access: exteriors only
Formerly a Dublin Metropolitan Police barracks, the building has
fine Scottish Baronial elevations, which have been confidently
handled to give scale and variety to a long street frontage. Over the
College Green and Pearse Street entrances are carvings of heads
in Dublin Metropolitan Police helmets and caps.

109
Iveagh Trust
Patrick Street, Bride Street, Dublin 8
1894–1915
Architects: various
Access: exteriors only
An ambitious rehousing programme by the Guinness family trust,
employing the London architects N.S. Joseph, Son & Smitherm;
the first three blocks between Kevin Street and New Bride Street
were begun in 1894 (supervising architect R.J. Stirling). A more
ambitious programme to clear the Bull Alley slum north of St
Patrick's Cathedral resulted in the creation of a new park and the
erection of Dutch gabled brick and terracotta blocks of apartments
on Werburgh Street and Nicholas Street (1901), the Iveagh Baths
and Iveagh Hostel (1904) (supervising architects Kaye Parry &
Ross). The centre-piece of the development, the Flemish baroque
Iveagh Play Centre (1915), was a competition-winning design by
McDonnell & Reid. The exuberance of the Iveagh Trust
development is in marked contrast to the austerity of the adjacent
scheme erected at about the same time by Dublin Corporation
(architect C.J. McCarthy). The Iveagh baths have been closed for
some years and are now in poor condition.

109

109

110
Gas Company
D'Olier Street, Dublin 2
1927
Architects: Robinson Keefe
Access: office hours

The best and most complete Art Deco design in Dublin, although
the original windows above street level shown in the illustration
have been replaced. The ground-floor glazing is elegantly framed
in chrome and the upper panels have designs etched into the
glass. Unfortunately the outer doors are not original. The windows
are articulated in vertical groups through the use of polished stone.
The showrooms, cash office and other public areas have retained
their original interiors. In contrast to the Art Deco façade, the
Hawkins Street elevation was completed by the same architects,
at the same time, in a mixture of Tudor and arts and crafts.

111
The Church of St Thomas
Cathal Brugha Street, Dublin 1
1931
Architect: Frederick Hicks
RIAI Gold Medal 1932–34
Access: exteriors and during church services only

This assured essay in Lombardo Romanesque was awarded the
first RIAI Gold Medal in 1935. Contemporary photographs show
the church as carefully scaled in relation to the surrounding
Georgian houses. Unfortunately these houses no longer exist and
the present surroundings of mainly commercial buildings are not in
harmony with the scale of the church.

112
O'Connell Street
Dublin 1

Lower O'Connell Street was largely destroyed in the 1916 Rising
and rebuilt in a variety of late-classical styles. Notable buildings
include: Allied Irish (formerly Munster and Leinster) Bank by
McDonnell & Reid (1917) with its Roman baroque cupola; Ulster
Bank by James Hanna (1923), the ground floor altered in the
1970s; Irish Permanent Building Society (originally Hibernian Bank)
by Ralph Byrne of W.H. Byrne & Son (1923), a unique mixture of
French Empire and Portuguese Manueline; Independent House in
nearby Middle Abbey Street has similar domes but is by Donnelly
Moore Keefe & Robinson (1921); Cleary's Department Store by
Ashlin and Coleman with Robert Atkinson (1921) is an excellent
example of the stripped classical style of the 1920s.

Upper O'Connell Street
Much of what survived the Rising was destroyed in the Civil War
(1922). Reconstruction was more orderly with height lines and
materials dictated by city architect H.T. O'Rourke. The Gresham
Hotel (1926) and adjacent Savoy Cinema (1930) are steel-framed
and faced with Portland stone; both were designed by London
architects – Robert Atkinson and F.C. Mitchell respectively. The

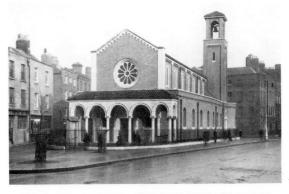

111

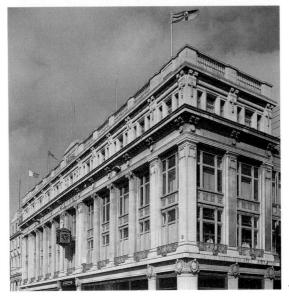

112

Parnell Monument (1911) was sculpted in New York by Augustus Saint Gaudens, with architectural assistance from Henry Bacon. The Carlton Cinema by Robinson Keefe (1938) boasts a virtually intact façade, at least above canopy level.

113
Irish National War Memorial
Islandbridge, Dublin 8
1940
Architect: Sir Edwin Lutyens
Access: Mon–Sun 10.00am–10.00pm (summer);
Mon–Sun 10.00am–dusk (winter)

One of the many great war memorials by Lutyens, the design consists of a series of granite structures set out in a unified classical composition in a garden setting dominated by a stone cross. A series of ponds and fountains are interspersed with stone pavilions linked by pergolas and arranged around a central feature. The complex was restored by Paul Sherwin, Office of Public Works, in 1988.

114
Dublin Corporation Flats of the 1930s
The work of A.G. Simms in the design and layout of public housing, is not widely recognized. His background in town planning is evident in the respect shown for the grain of the city. Blocks of low-rise flats maintain street lines, and monotony is avoided by the introduction of formal courtyards, as in Oliver Bond House, and in the provision of new landmarks such as the Rental Office House on the corner of Cook Street and Lower Bridge Street. The use of local bricks and the careful detailing, in the striped classical style of the period, is strongly influenced by the Amsterdam School. Simms' last scheme, Fatima Mansions, has particularly fine massing and composition with international style influences. Other examples of his work include Townsend Street, 1938; Chancery Place, 1938 and Watling Street, 1938. It was not until the 1970s that the housing schemes designed by Dublin Corporation regained the concern for urban and architectural values exemplified in the work of A.G. Simms.

115
Post Office
Andrew Street, Dublin 2
1949
Architects: S. Maskell and J. Fox, Office of Public Works
Access: post office hours

The well-mannered granite and stone façade contains five castings depicting the functions of the building. Internally the structure, materials and artificial light are orchestrated in a strong and effective manner. A high standard of detailing is evident throughout the building, even in the areas not frequented by the public.

113

115

116

Arus Mhic Dhiarmada, Busarus

Store Street, Dublin 1
1947–50
Architect: Michael Scott
RIAI Gold Medal 1953–55
Access: office hours

Built between 1947 and 1950, Busarus was the first major work of modern architecture in post-war Dublin. Influenced by Le Corbusier and the early International Modern Style, its architectural significance was immediately recognized outside Ireland. The building was designed to house a bus terminus, government offices and a small theatre, the latter of which has been closed for many years. Constructed of reinforced concrete with Portland stone cladding, Busarus remains one of the landmarks of modern architecture in Ireland.

117

Liberty Hall

Beresford Place, Dublin 1
Architect: Desmond Rea O'Kelly
Access: office hours

Purpose-built as office headquarters for the Irish Transport & General Workers Union (now SIPTU), it is located along the Liffey Quay, beside Butt Bridge and the Custom House. Liberty Hall was the first high-rise building in the city and its location dominated the riverine landscape. In its time the building symbolized the birth of a new economic era. However, its height within the low-rise urban context of Dublin was greatly criticized and no further development of this nature has been permitted within the core of the city.

118

Bord Failte

Baggot Street, Dublin 2
1961
Architects: Robin Walker, Michael Scott & Partners
Access: office hours

This small office block was built to house the headquarters of the National Tourist Board. Located on a prominent corner site alongside the Grand Canal at the edge of the inner city, the building is distinguished by careful detailing and use of materials, good proportions and strict adherence to an abstract concept. It is a seminal work of its type in Ireland. Square in plan, with a central core, the building is five storeys over basement with an exposed reinforced-concrete frame.

119

Abbey and Peacock Theatres

Marlborough Street, Dublin 1
Architects: Michael Scott & Partners
Access: theatre hours

Built to rehouse the famous Abbey Theatre, the building is located on a corner site between Abbey Street and the Liffey. The Theatre corresponds in height to the adjoining buildings, and is a blank box

116

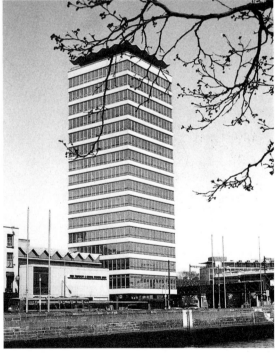

117

of grey concrete brick with no relief other than at door level. Its genesis lies in the work of Mies van der Rohe. A two-storey stone-clad portico was added to the Abbey Street façade in 1990 by McCullough and Mulvin, architects.

120
Trinity College
College Green, Dublin 2
Access: generally possible to public areas only and on application otherwise

(a) New Library
1967
Architect: Paul Koralek, Ahrends Burton Koralek
The design was the winning entry in an international competition: it is a granite and concrete building deceptively small in appearance and with a spatially dynamic interior.

(b) Arts Building
1980
Architect: Paul Koralek, Ahrends Burton & Koralek
The building completes a new college quadrangle, gives an urban edge to Nassau Street and provides a much used additional entrance to Trinity College Dublin.

(c) Atrium
1985
Architects: de Blacam and Meagher
Europa Nostra Award, 1988
Built in conjunction with the restoration of the Dining Hall it is notable for its the elegant timber structure and screens. The restoration is also notable for the quality of the detailing and a re-creation of the Kartner Bar.

(d) The O'Reilly Institute
1988
Architects: Scott Tallon Walker
Visible from Westland Row and Pearse Street, this glass and panel-clad building houses offices and laboratories around two glazed atria.

(e) Sports Centre
1984
Architects: Scott Tallon Walker
Influenced by the work of Mies van der Rohe at the Illinois Institute of Technology, the building is an exposed steel frame with concrete panel and glass infill; steel diagonal bracing is expressed externally.

(f) The William Rowan Hamilton Building
1992
Architects: Scott Tallon Walker
Named after one of the university's most famous scientists, and completed to mark the fourth centenary of the founding of the College, the building houses Trinity College Dublin's Science and Engineering Library and five lecture theatres following the masterplan established for the O'Reilly Institute. A complex range of functions is carefully organized with the structure rigorously expressed.

119

119

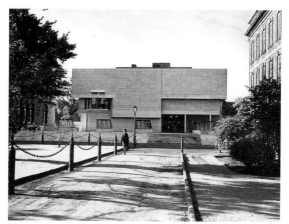

120a

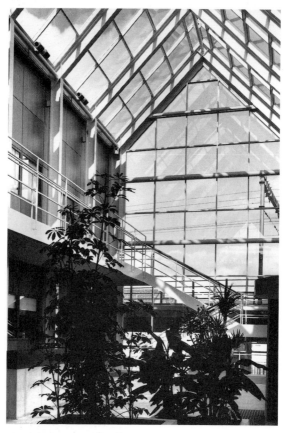

120d

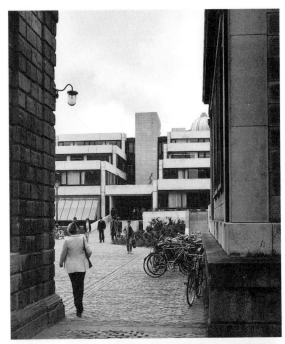

120b

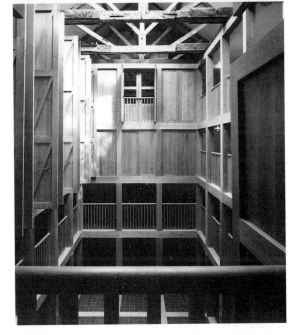

120c

120f

121
Electricity Supply Board Headquarters
Lower Fitzwilliam Street, Dublin 2
1969
Architects: Stephenson Gibney & Associates
Access: Tues–Sat 10am–5pm; Sun 2pm–5pm (number 29)
This is a competition-winning design and is an early example of
infill within a Georgian terrace. The building respects the height and
colour of its neighbours; it is clad in pre-cast concrete panels with
dominant vertical fins between windows. The building was the
product of an era in which Dublin's Georgian heritage was not
regarded as highly as it is today. To the rear of the building is a later
stone-clad extension by Stephenson Associates, 1982. Existing
Georgian row houses, Lower Fitzwilliam Street and Upper Mount
Street, were restored by Stephenson Reddy Associates,
architects, in 1990. Number 29, built in 1794, was renovated in
1991 as a museum of Georgian Dublin and has been furnished as
a typical house of the period 1790 to 1820.

122
Stephen Court
St Stephen's Green, Dublin 2
Architect: A. Devane, Robinson Keefe & Devane
Access: exteriors only
Another example of an infill office development, the context for this
building, along St Stephen's Green, is partly Georgian and partly
Victorian. The building reflects the height of its neighbours and is
brick-clad with vertically-proportioned windows. An arched arcade
in exposed white concrete at ground level, provides a base to the
building. An attractive garden to the rear of the building is visible
from street level.

123
Lisney Building
24 St Stephen's Green, Dublin 2
1973
Architect: R. Tallon, Scott Tallon Walker
Access: exterior only
A further example of infill within a city square, this building uses
scale and proportion rather than materials to harmonize with the
urban framework. The building is finished in white painted steel
panels with exposed steel stanchions, in the style of Mies van der
Rohe.

124
Bord Bainne
Grattan House, Lower Mount Street, Dublin 2
1972
Architects: Stephenson Gibney & Associates
Access: exterior only
A brick-clad office headquarters on a corner site adjacent to the
Georgian area of the city, the façade treatment allows the building
to harmonize with its environment without depending on pastiche
elements. The Georgian character of Lower Mount Street has been

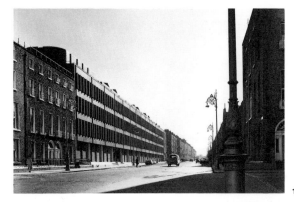

121

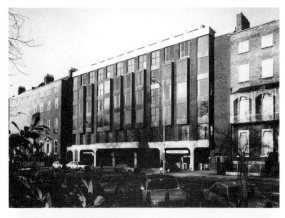

122

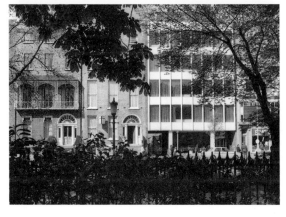

123

lost in recent years by a mixture of late 20th-century office
buildings of varying architectural standards.

125
Bank of Ireland Head Office
Baggot Street, Dublin 2
1968–75
Architect: R. Tallon, Scott Tallon Walker
Access: banking hours
The building complex was erected in two phases between 1972
and 1979. It consists of three slab blocks, of varying heights,
arranged around a central plaza which creates a new public space
along the Georgian façade of Baggot Street. The buildings are in
the style of Mies van der Rohe's Seagram Building in New York and
are one of Europe's finest examples of work within that idiom.
Bronze stanchions and cladding panels are used externally.

126
Educational Building Society
Westmoreland Street, Dublin 2
1976
Architects: Stephenson Associates
Access: office hours
Located within the commercial heart of the city, the architect has
retained part of an original Victorian stone façade. A glass and
stone curtain wall clads the rest of the façade, contrasting with and
reflecting its neighbours.

127
Irish Life Centre
Lower Abbey Street, Dublin 1
1977–86
Architect: A. Devane, Robinson Keefe & Devane
Access: office hours
This complex of buildings was one of the first examples of
comprehensive redevelopment within the inner city. It contains
office space, housing and sports facilities together with shops and
a shopping mall at ground level. It also houses an extensive
underground car park. The complex consists of a number of brick-
clad blocks of varying height which create squares and plazas
within the development. One plaza along Beresford Place is open
to the public and forms a new civic space. In general, the complex
respects existing street lines and building heights.

128
Bord Na Mona Headquarters
Baggot Street, Dublin 2
Architect: S. Stephenson, Stephenson Gibney & Associates
Access: office hours
A curtain wall of glass and stone wrap this L-shaped office building
in the sophisticated skin of corporate America. The inventive
entrance garden is reminiscent of the work of the Irish American
architect Kevin Roche.

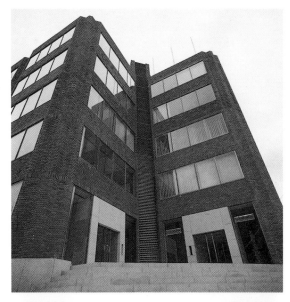

124

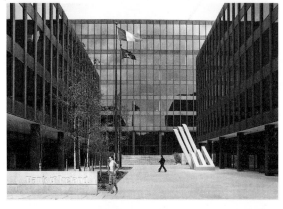

125

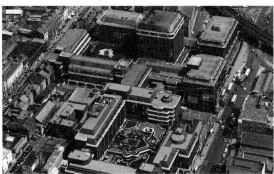

127

129
Coombe Housing
Dublin 8
1978
Architects: Delaney McVeigh & Pike
High-density, low-rise housing which maintained urban forms and streets and kept communities intact was an architectural aspiration of the late-1960s and 1970s. This is Dublin's purest example of the genre, with strongly modelled brick façades, internal pedestrian paths and well-located corner shops.

130
City Quay Housing
City Quay, Dublin 8
1979
Architects: Burke-Kennedy Doyle
RIAI Housing Medal 1979–81
A competition-winning design which exemplified the new community-conscious social housing schemes of the 1970s and 1980s. It recreates the small-scale streets and brick façades of traditional inner city residential enclaves. The 1975 City Quay Housing Competition was an important watershed in the development of inner city housing in Dublin as it marked an end to rigid imposed forms and the beginning of new a concern for urban form and context.

131
New Street/Clanbrassil Street Housing
Dublin 8
1980
Architects: Delaney McVeigh & Pike
Another complex of two-storey and three-storey brick houses in the traditional pattern. It is built around a system of small-scale squares and creates a strong urban edge in a previously derelict part of the city close to St Patrick's Cathedral and the old Liberties of Dublin.

132
Irish Distillers Group Headquarters
Bow Street, Dublin 7
1979
Architects: B. O'Halloran & Associates
Access: exterior only
This is an innovative renovation of the old John Jameson Distillery building to accommodate modern office use. The building is located on Smithfield Market close to the Liffey and its opening heralded the slow rediscovery and regeneration of this previously run-down area of the inner city. The Smithfield area was the focus of a major International Architectural Ideas Competition run by the RIAI and Powers Gold Label in 1991.

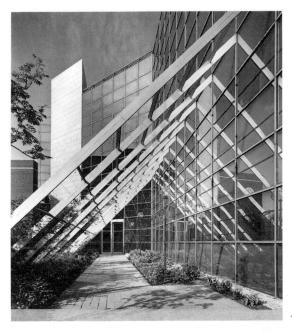

128

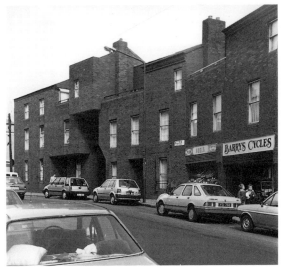

129

133
Central Bank
Dame Street, Dublin 2
1978
Architect: S. Stephenson, Stephenson Gibney & Associates
Access: general banking hours
The suspended structure of this large stone and glass-clad building is unique in Dublin. The height and architectural expression of the building was the subject of much controversy in the late-1970s and early-1980s. While the impact on Dublin's skyline may be questioned, this is a forceful and beautifully detailed architectural concept. The building is set back from the street façade to create a new urban plaza which now provides a gateway to the Temple Bar area.

134
PMPA Offices
Woulfe Tone Street, Dublin 1
1980
Architect: R. Walker, Scott Tallon Walker
Access: office hours
A purpose-built office building accommodating a motor insurance corporation, the building is noteworthy for the elegance and fine detailing of the steel and glass façade to the street elevation.

135
Port and Docks Headquarters
Alexandra Road, Dublin 1
1981
Architect: N. Scott, Scott Tallon Walker
Access: exterior only
The building is located in the old dockland area to the north-east side of the river. Many of the dockland facilities have now moved downriver and the area is slowly becoming a centre of light industry. The building is free-standing with an exposed, trebated concrete structure, clearly articulated and finely detailed.

136
Life Association of Ireland
Dawson Street, Dublin 2
1982
Architects: Ryan O'Brien Handy
Access: office hours
A brick-clad office building inserted into the mixed Georgian and Victorian façades of Dawson Street, this example of urban infill successfully attempts, without pastiche, to reinterpret the traditional elements of Dublin street architecture.

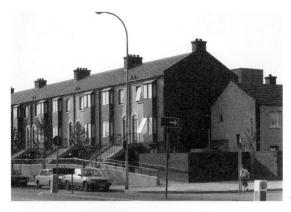

130

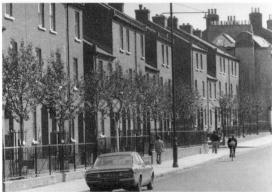

131

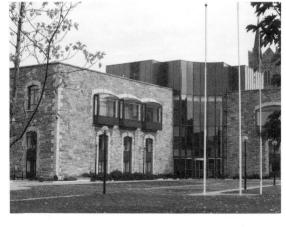

132

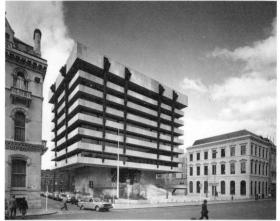

133

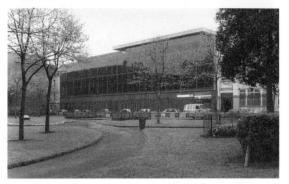

134

135

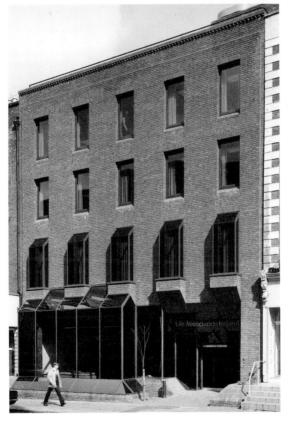

136

137
Ulster Bank
College Green, Dublin 2
1982
Architects: Boyle & Delaney
Access: general banking hours
The building occupies a large and irregular site with frontages on
three streets. It is stone-clad throughout with a private central
atrium space. Each façade attempts through variations in detail
and proportion, to relate to the mixture of architectural expression
and scale in the adjoining streets.

138
Industrial Development Authority Enterprise Centre
Pearse Street, Dublin 2
1983
Architects: Barry & Associates
Access: office hours
Built to house a group of small innovative industrial and
commercial units, the development is located alongside the now
abandoned dock area to the south-east of the river. An existing
19th century stone warehouse has been renovated for office and
commercial use and forms the heart of the complex.

139
National College of Art and Design
Thomas Street, Dublin 8
1984
Architects: Burke-Kennedy Doyle Architects
Access: office hours
A new urban campus has been cleverly fitted into the old stone
and brick buildings which were built to house the Powers Distillery
founded by John Power in the late 18th century. Part of the
proposed campus, designed by Peter and Mary Doyle has yet to
be built.

140
Kinnear Court
Cumberland Street, Dublin 2
1984
Architects: Keane Murphy Duff
Access: exterior only
This building displays an inventive and unusual solution to the
difficult problem of urban infill. Set back from the street, the new
office block is notable for its attractive colourful windows and bold
expression of circular concrete columns.

141
Dublin Corporation Housing 1970s/1980s
The late 1970s were an important watershed in the design of inner
city housing in Dublin, the influence of which released architects
within the Corporation from the rigid inherited constraints of the
city block housing of the 1960s. Following the housing competition
for City Quays (see entry number 130) and increasing government

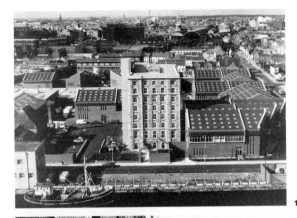

138

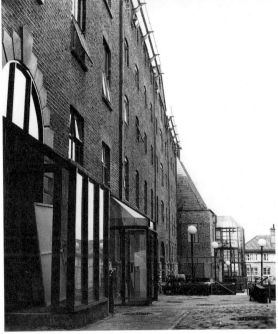

139

commitment to public housing, schemes began to show the relaxation of previously rigid rules on housing. As with the work of A.G. Simms in the 1930s, there was a renewed concern for urban form and streetscape. Typical schemes of this period include:

(a) Sherrard Street/Portland Street Housing
Dublin 1
1979
Architects: J. Maguire, D. Gilligan and C. O' Runaidh,
Dublin Corporation Housing Architects' Department
A carefully considered series of linked pedestrian spaces surrounded by one-, two- and three-storey houses.

(b) Rutland Street Housing
Dublin 1
1985
Architects: J. McDaid, C. Crimmins, B. McConville and J. Green, Dublin Corporation Housing Architects' Department
In this scheme, Dublin street forms are innovately recreated and carefully related to existing street patterns. The main street is aligned with the axis of the Free Church and in the central space incorporates a pavement sun-dial.

(c) Bride Street Housing
Dublin 8
1985
Architects: J. McDaid, D. O'Connor, S. Goggin and M. Gormley, Dublin Corporation Housing Architects' Department
In this scheme, disciplined forms are used to create a formal enclosure to St Patrick's Park.

(d) Russell Street Housing
Dublin 1
1986
Architects: J. McDaid, B. Grimes, M. McNally and M. Connor, Dublin Corporation Housing Architects' Department
A complex range of housing types which are grouped around a private courtyard.

142
Civic Offices
Wood Quay, Dublin 2
1986
Architect: S. Stephenson, Stephenson Gibney & Associates
Access: public areas during office hours
This is a winning entry in a Developer Design/Build competition held in 1967 for the provision of new centralized offices for Dublin Corporation. The location of the offices on a site of major archaeological significance has been the cause of considerable public controversy. The archaeological remains are now displayed in part of the complex. It is difficult to assess this complex because only two of the four towers were completed but the simple sculptural forms, with their limited relationship to the existing grain of the city, are very much of their time. In 1992 a limited competition was held to complete the Civic Offices which was won by Scott Tallon Walker with a design that provides a strong civic building along the river frontage, and successfully integrates the existing blocks. Shown here is the winning entry in the 1992 competition.

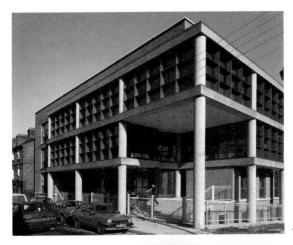

140

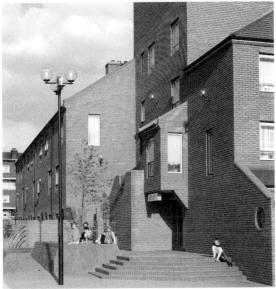

141a

143
St James Hospital
James Street, Dublin 8
1987
Architects: Moloney O'Beirne, Guy Hutchinson Locke & Monk
Access: public areas only, during normal hospital hours
A new hospital complex resulting from the amalgamation of several
long-established city-centre hospitals, it is an on-going
development using brick, pitched roofs and attractively
landscaped courtyards to create a non-institutional environment.

144
Courthouse
Smithfield, Dublin 1
1987
Architect: J. Tuomey, Office of Public Works
Access: court hours
The square entrance façade is designed to continue the pattern of
the neighbouring houses and to make a public building intelligible
by translating the liner sequence of the plan onto the vertical
arrangement of the elevation. Parts of the façade, such as the pair
of columns and the glass canopy, refer to key elements in the
interior.

145
Clanwilliam Square
Grand Canal Dock, Dublin 2
1988
Architect: J. O'Connor, Arthur Gibney & Partners
Access: exteriors only
The over-supply of office space in the 1980s led to the
development of a number of small-scale owner-occupied
developments throughout the city. This is one of the more
successful examples, where new buildings are aligned along
existing street frontage and are used to create new squares and
canal-side terraces in an imaginative re-use of traditional form.

146
Earlsfort Centre Development
1986–91
Architects: Burke-Kennedy Doyle & Partners
Access: exteriors and Conrad Hotel
Built on a large triangular site at a corner of St Stephen's Green,
this massive redevelopment scheme contains offices, apartments,
an aparthotel and the new Conrad Hotel. The nucleus of the
complex, is a new sunken urban piazza on Earlsfort Terrace facing
the National Concert Hall. Individual buildings within the scheme
are elevated to reflect the character and scale of the original street
façade. In some instances, the façades are accurate reproductions
of those which they have replaced.

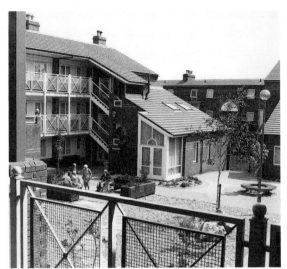

141c

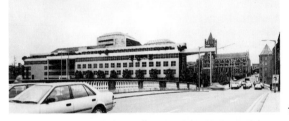

142

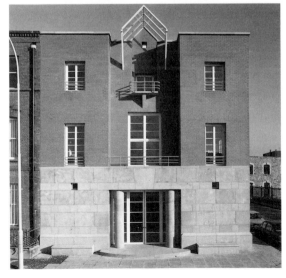

144

147
Offices, Ormond Quay
1989
Architects: Grafton Architects
Access: exteriors only

This is a fine example of urban infill on a small site along the Liffey Quays. At ground level the building retains the stone front wall of a former 19th century Presbyterian church. Built of brick, with stone and plaster bands and double-height columns and windows at the middle floors, the front façade reinterprets the character and scale of its Georgian and Victorian neighbours.

148
Bolands
1991
Architects: Henry J. Lyons & Partners
Access: exteriors only

Boland's Bakery was a purpose-built, brick clad building of the 1940s with a strong industrial image. It has been reconstructed to accommodate modern office facilities and its external expression has been radically altered.

149
Beresford Court
Irish Life Offices, Beresford Place
Architects: A. & D. Wejchert
Access: exteriors only

Corporate offices using fine materials, carefully detailed and crafted, to create a building of dignity and strength on a difficult corner site. The space between this and the adjoining VHI building contains a four-storey atrium winter garden under the glazed roof, which acts a focal point for the entire complex.

150
Aranus AB
65/66 Lower Baggot Street, Dublin 2
Architects: A. & D. Wejchert
Access: exteriors only

An innovative infill scheme for a speculative office building: a play of modern, almost mannerist elements, against a traditional façade. The ground floor has a heavy stone base from which a delicate curtain wall emerges centrally through a brick wall which steps back at each level. Its central projecting bay window is capped in copper in dialogue with the nearby Holles Street Hospital.

151
Irish Film Centre
Eustace Street
1992
Architects: O'Donnell and Twomey

The Irish Film Centre is housed in a former Quaker building and accommodates two cinemas, a film archive, specialist shops, a restaurant, a bar and offices. The complex has no significant street

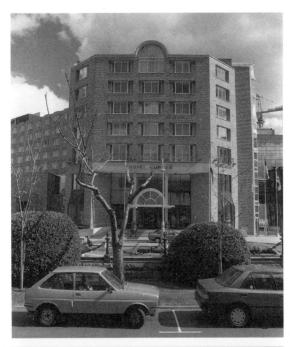

146

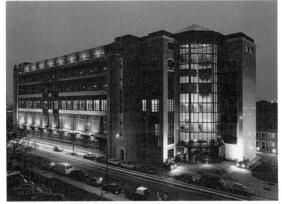

148

frontage and the architects have provided a route through the complex leading to central glazed space with the quality of an external courtyard around which the main areas are grouped. New elements are treated as installations and contrast with the existing buildings to provide an appropriate and interesting environment.

152
Temple Bar
1992

Temple Bar is bounded to the north by the Liffey, to the south by Dame Street, to the east by the Bank of Ireland and to the west by Parliament Street. A significant area of the site was owned by the state transport company and there was a proposal to build a major transportation centre on the site. This was abandoned and the government established a development company, Temple Bar Properties Ltd with the objective of promoting development within the context of four framework plans. These are:

1 an architectural framework plan
2 a cultural and community framework plan
3 a property framework plan
4 a cultural framework plan

A limited competition was held in 1991 for an architectural framework plan which was won by Group 91. Group 91 are presently engaged in a number of projects, due for completion in late 1993 including a new curved street, a Multi-Media Centre, a Music Centre, Meeting House Square with a Children's Centre and the National Photographic Gallery. In addition Group 91 and a wide range of other architects, including O'Dowd, O'Herlihy Horan, Scott Tallon Walker and Burke Kennedy Doyle, are involved in other projects including a new pedestrian bridge over the Liffey, a craft centre, Temple Bar galleries and studios, a Viking centre, a car-parking building and other residential and commercial projects.

David Mackay, one of the competition assessors, commented, 'The Temple Bar architectural competition for a framework plan is in our opinion extremely significant. The object of the competition is revolutionary; it returns to the historical tradition of considering that the design of public space, streets, squares, and their sequence and proportions are a subject of cultural importance to the identity of the city and are therefore a public responsibility'.

153
Waterways Visitors Centre
Grand Canal Basin
1992
Architects: C. O'Connor and G. O'Sullivan,
Office of Public Works

The Waterways Visitors Centre is an Interpretive Centre for all waterways in Ireland and is also intended as a 'pump priming' exercise in ambitious development plans for the development of this largely derelict area. The building has a distinct nautical character and appears to float on the water. The ship metaphor is continued by the contrast between the machine aesthetic of the

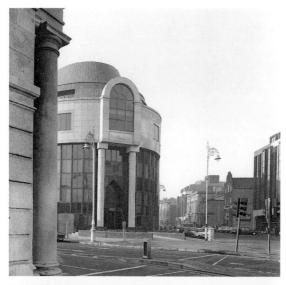

149

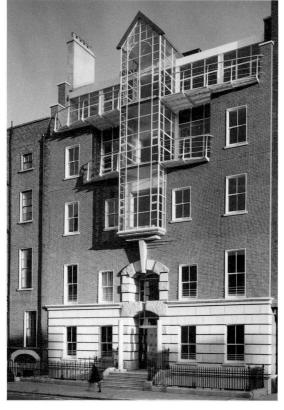

150

exterior and the hand-crafted Irish timber interior which refers to ship fitting-out detailing. The interpretive elements are particularly well integrated as these have been designed by the architects and include working models of the Shannon, the canal system, artefacts, historical information etc.

Significant building complexes outside the inner city

154
Dublin Airport
Swords, County Dublin (Bus No. 41)
Access: exteriors only and on application

Old Terminal Building
1940
Architect: Desmond Fitzgerald, Office of Public Works
RIAI Gold Medal 1938–40
This was the first building of the new national airline Aer Lingus. Under the direction of Desmond Fitzgerald, an architectural team including H. Robson, D. O'Toole, C.G. Henry, P. Murphy, K. Barry and C. Kelly, designed this pioneering building in a confident international style. The elegant and meticulous design, for what was then a relatively new building type, did not receive the international recognition it deserved when completed in 1940, due to war time censorship. It was only after the war that information and photographs were first published. This entire project was a deliberate attempt at 'total design' with the architects choosing fabric, cutlery and even menu cards. The building is a nostalgic reminder of a time when air travel was exciting, glamorous and without security problems.

155
Radio Telefis Eireann
Stillorgan, County Dublin
Architect: R. Tallon, Scott Tallon Walker
In 1960 Radio Telefis Eireann was established by the government to inaugurate a national television service and to take control of the former Radio Eireann. An 18 acre site on the south side of the city was acquired to provide this facility and since this time has continued to develop following a master plan by Scott Tallon Walker. The first building completed in 1961 was the television studio. A Scene Dock Building and Administration Building were added in 1967. A new Radio Centre was completed in 1973 and the original television studio building doubled in size. The latest building was completed in 1990 and provided a new sound stage and associated facilities. Careful site planning, clear organization, the use of a standard 20 foot grid and the quality of materials used has produced a complex of high quality. Access to the complex is on application only, but the buildings can be viewed from the road.
(a) RTE Television Building 1962, extended 1973
There are three levels in the building, clearly separated by function. The two main studios run through two storeys, ground floor and first floor, up to the bottom of the lighting and scenery grids, and

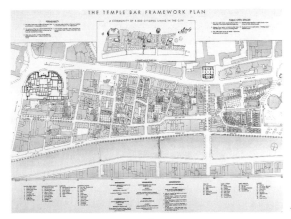

152

153

the third floor occurs over these only, expressing outside their location within the building. All technical areas are on the first floor, with control rooms overlooking the studio floors below. Dressing rooms, workshops and scenery stores are on the ground floor, for easy access to the studios at studio level. Perimeter colonnades giving covered access to all studios and workshops were designed to retain this function, becoming through roads under the first floor, as the building expanded. The building in notable for clear expression of function and structure and elegance of proportion and materials.

(b) Administration Building 1967

The Administration Building has three floors of offices over a colonnaded ground floor. Structure and form are rigorously expressed in the building.

(c) Restaurant Building 1967

A simple plan form generated by the screen wall to the kitchen area which penetrates the glazed box of the restaurant.

(d) The Radio Building 1973

A complex range of functions are resolved into a single storey and offices, raised on a podium recessed behind the office level providing semi-underground technical facilities where extra sound-proofing is required. The principal studio, the height of both floors combined, projects through the roof.

156

University College Dublin

Stillorgan, County Dublin

In 1949 it was decided to move University College Dublin from its overcrowded buildings at Earlsfort Tce, (entry number 107), to a new 300 acre site at Belfield, 4 miles south from its original situation in the centre of Dublin. An International Architectural Competition was held in 1964 for a master plan for the new Campus and for the design of the Arts, Administration and Aula Maxima building (a). The competition was won by A. & D. Wejchert, from Warsaw who have been in practice in Ireland since that date.

The Assessors Report described the buildings in the winning entry as being 'arranged at either side of a pedestrian mall of interesting and irregular shape. The proposed development of the buildings for the various facilities on both sides of a pedestrian mall allows for a logical succession of the buildings required, whilst leaving between them the views of courtyard and landscapes'. The overall plan was based on a linear development of the campus linking the buildings together by covered walkways. The buildings are sited as close as is reasonably possible to each other in order to maintain a walking distance of approximately six minutes (500 metres) between the two ends of the mall. The close siting also helps to limit the underground service runs and roadwalks. A ring road encircles the campus core which is pedestrianized.

Over the years there have been modifications to the master plan due to changing circumstances so that the campus lacks some of the rigour and clarity of the original concept. However, the unity of the campus during its development, which is phased over twenty years, has been largely maintained due to the disciplined

155a

155b

use of external finishes and extensive landscaping. A number of architectural practices have designed buildings for the campus. There is open access to the campus and public areas of most buildings can be visited during term time.

(b) Arts and Commerce Building

1970

Architect: A. & D. Wejchert in association with Robinson Keefe and Devane

Completed as a result of the Belfield Architectural Competition, the building was planned for 5000 students and provides adaptable standard teaching units grouped around inner courtyards and interconnected with a service/circulation tower. The lower two floors contain eleven lecture theatres. The organized relationship between function, structure and service is clearly expressed throughout the building both externally and internally.

(c) University Restaurant

1970

Architect: R. Walker, Scott Tallon Walker

RIAI Gold Medal 1968–70

This elegant building is sited in a hollow which provides an opportunity to create a three tier section with the main entrance and common spaces at the middle level. The upper floor is the main level for serving full meals and can be adapted for social functions. A fine proportion has been achieved in the rigorous expression of the structural elements, contrasting with the horizontal floors which appear to float in the air.

(d) The Administration Building

1972

Architect: A. & D. Wejchert

RIAI Gold Medal 1971–73

The Administration Building was also built as a result of the Belfield Architectural Competition and provides centralized administration services for the campus. In addition to normal university work it is used by academic staff, students and visitors and houses the office of the President, Registrar, Secretary and the Governing Body. The building is organized around a dominant central space and is noteworthy for high-quality internal and external concrete finishes and for the dynamic quality of its internal spaces.

(e) Water Tower

1972

Architect: A. & D. Wejchert

The water tower is the most conspicuous landmark on the campus. The 60 metre high pentagonal stem of reinforced concrete is of particularly high quality, constructed in one pour utilizing a sliding shutter. The tank, in the form of a duodecahedron, provides a strong termination to the tower shaft and transforms a functional object into a clear sculptural form.

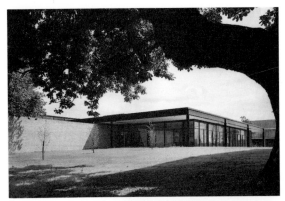

155c

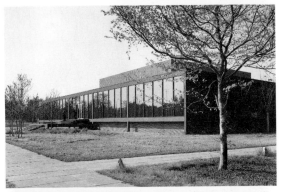

155d

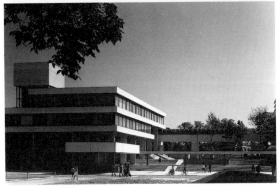

156a

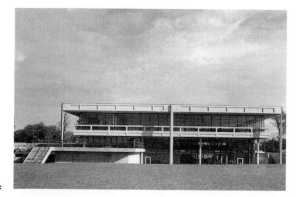

156c

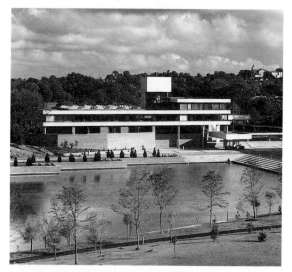

156d

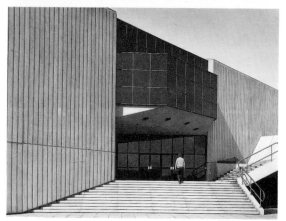

156f

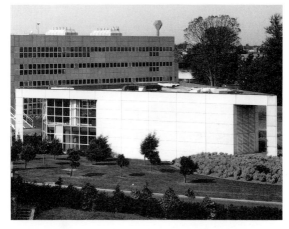

156g

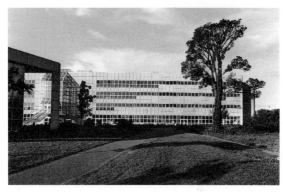

156h

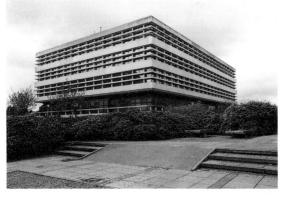

156i

(f) Sports Centre
1981
Architect: A. & D. Wejchert

The Sports Centre was designed to cater both for the recreational needs of students and for major university functions. It consists of two elements: a sports hall and a field games changing area. A third element, the swimming pool, has yet to be built. The building successfully integrates complex functional requirements and is notable for the spacious open interior where spectators are encouraged to watch the various activities from the many galleries. The carefully-detailed high-quality materials have successfully withstood intensive use.

(g) The Industry Centre
1986
Architects: Scott Tallon Walker

Designed to accommodate a forum for interaction between industry and the university, the Industry Centre has a 250 person lecture theatre, conference and exhibition facilities. The triangular plan form gives presence and scale to what is a small building on the campus and the geometric complexity inherent in a triangular form is carefully resolved.

(h) School of Engineering
1989
Architects: R. Tallon, Scott Tallon Walker

The School of Engineering, University College Dublin is one of the biggest construction projects ever initiated by the state and was nearly fifteen years in gestation. The first stage of 13,000 sq m was completed in 1989, the second phase of 11,900 sq m is yet to be commissioned. The building is planned as a north–south multi-level hall with two arms of accommodation stretching perpendicularly westward enclosing a single-storey wide-span workshop. The building is designed on a planning grid of 1200 x 1200mm with the main structure in reinforced concrete. The central glazed street unifies the disparate elements of this large and complex building, which is beautifully and thoughtfully detailed. Other buildings on the site include: The Agricultural Faculty Building, 1970, by P. Rooney & Associates (i), Library, 1972, by Basil Spencer & Partners, Bank of Ireland by A. & D. Wejchert 1973, Chaplaincy Building, 1990, by Cathal O'Neill & Partners (j), and Student Housing, 1991, by Burke-Kennedy Doyle (k).

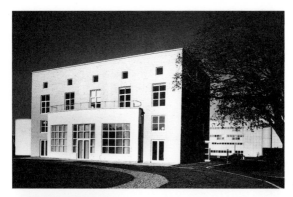

156j

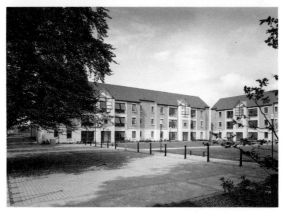

156k

Illustration credits

Illustrations are reproduced with the permission of the following:

H. Doran 1, 29, 45, 60, 63, 66

Davison & Associates 3, 6, 13 (right), 16, 20, 23, 26, 30 (top), 38, 40, 44, 46, 49, 89

Bord Failte 4, 5, 8, 22, 25 (p.39), 47, 51–53, 56, 76, 93

Pieterse-Davison 7, 120c, 127, 156a, 156d

IAA 9, 10, 13 (left), 17–19, 21, 25 (pp.40–41), 27, 28, 30 (bottom), 32–37, 39, 41, 43, 48, 55, 56, 58, 62, 65, 67–70, 73, 74, 78, 81, 82, 84–86, 90, 92, 94, 96, 98, 99, 101, 104, 109, 113, 119 (top), 121

Sally Kerr Davis 11

B. Hastings 14, 106, 112, 119 (bottom), 136

OPW 24, 75, 153

RIAM 35

F. Fennell 42

P. Barrow 50, 77, 79, 80, 91, 100

Fr. Browie SJ 57

National Irish Bank 71

P. Walshe 97

B. Mason 105

L. Pieterse 111

An Post 115

STW 116

D. Rea-Kelly 117

J. Donat 120d, 120f, 123, 125, 134, 135, 155a, b, c, d, 156c, h

A.F. Rattoul 120a, 120b

RKD 122

Bord Bainne 124

N. McGrath 128, 133

DPM 129, 131

BKD 130, 139, 146

BOH&A 132

Cusack 138

KMD 140

Dublin Corporation 141

D. Murphy 142

Irish Times 144

M. Blake 148

PDI 149, 150

Kingram Studios 156f

B. Mason 156k

Index of Architects

Subject Index

Map 1 Central Area

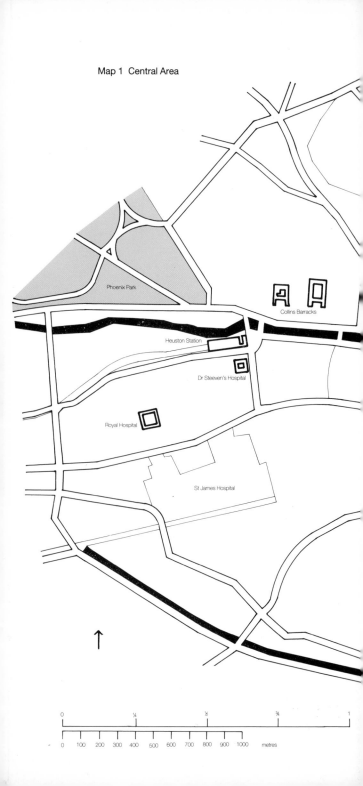

Phoenix Park

Collins Barracks

Heuston Station

Dr Steeven's Hospital

Royal Hospital

St James Hospital

| 0 | ¼ | ½ | ¾ | 1 |

| 0 | 100 | 200 | 300 | 400 | 500 | 600 | 700 | 800 | 900 | 1000 | metres |

Map 3 Trinity College

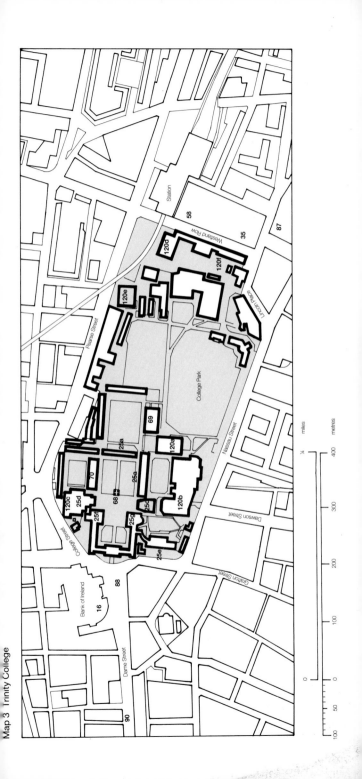

Map 4 Georgian Squares, north city

Mountjoy Square

North

East

West

South

Gardiner Street

38

34

Gardiner Street

41

Denmark Street

86

29

North

Dorset Street

Redmond Hospital

East

22

Parnell Square West

26

South

Parnell Street

O'Connell Street

17

106

King's Inns

0 50 100 miles

0 100 200 300 400 metres

¼

Map 5 Georgian Squares, south city

Merrion Square North
30
Merrion Square
West
Leinster Lawn
76
21
96
9
105
55
Kildare Street
89
122 123
North
St Stephen's Green
East
South
Dawson Street
93
44
81
St Stephen's Green West
Cuffe Street
73
31
19
18
107
146
Iveagh Gardens
Camden Street
Harcourt Street
Leeson Street
Pembroke Street
Fitzwilliam Street
Baggot Street
Fitzwilliam Square
47
East
South
Merrion Street
Mount Street Upper
Mount Street Lower
121
125
65
150
128

0 50 100
0 100 200 300 400 metres
0 ¼ ½ miles

Map 6 Victorian Commercial Centre

Map 1 University College Dublin

To city centre

Main entrance

Stillorgan Road

To south city suburbs

metres

miles

| 100 | 50 | 0 |
| 0 | 100 | 200 | 300 | 400 |

0 ¼ ½